Folk Art

FUSION

LEARN TO PAINT COLORFUL CONTEMPORARY FOLK ART IN ACRYLIC

By Heather Galler

Quarto is the authority on a wide range of topics.
Quarto educates, entertains, and enriches the lives of our readers—
enthusiasts and lovers of hands-on living.
www.quartoknows.com

6 Orchard Road, Suite 100
Lake Forest, CA 92630
quartoknows.com

Visit our blogs at quartoknows.com

Printed in China

1 3 5 7 9 10 8 6 4 2

MIX
Paper from
responsible sources
FSC
www.fsc.org FSC® C101537

Table of Contents

Find all of the templates in this book at www.quartoknows.com/page/folk-art

Introduction

As an artist, I love learning about other cultures and customs, and I am always looking for new ways to be inspired. To me, folk art is an untapped well of inspiration—it is art that represents a person's history and traditions.

Folk Art Fusion will take you through the process of how I created 16 folk art paintings inspired by different countries and cultures around the world, including China, Japan, Mexico, Russia, Sweden, the United States, and others. Each subject in the book was carefully selected because it inspired me.

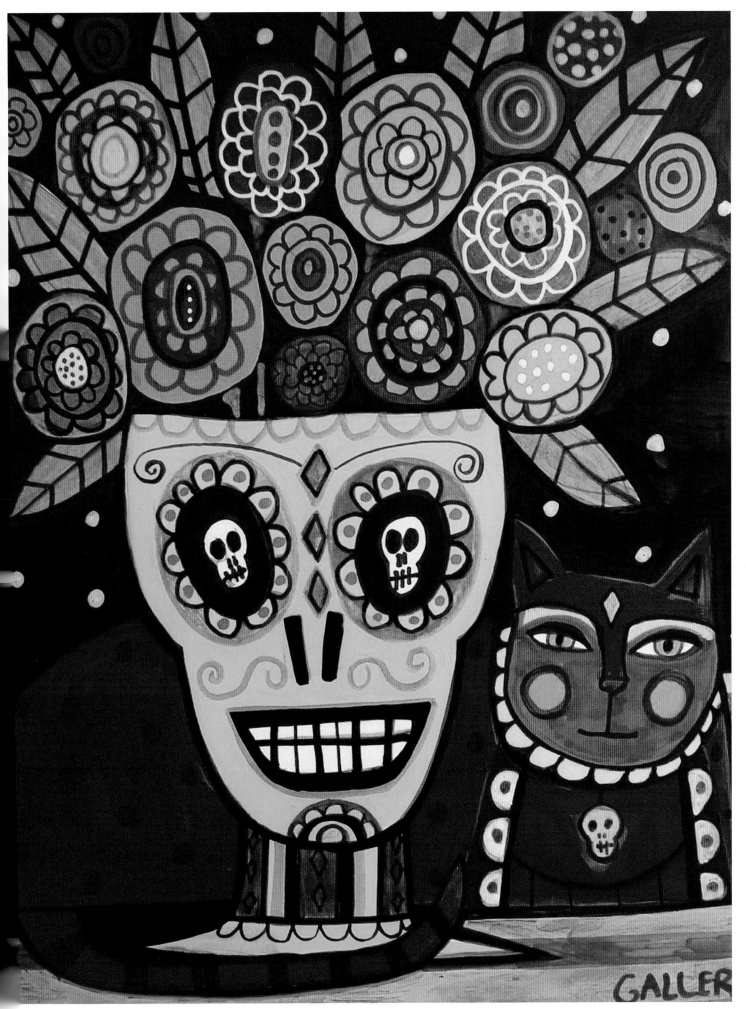

What is Folk Art?

Everyday people creating extraordinary works of art—this is the basis of folk art. Folk art relies on experience, community, and heritage rather than formal training. It is art that is felt rather than taught. Deeply rooted in tradition, folk art is an artist's feelings, ideas, expressions, and customs brought to life.

The term "folk art" was used during the 1700s and 1800s to describe art made by craftsmen, manual laborers, peasants, tradespeople, and working-class folk. These artists were untrained or had very little schooling in fine arts, but some had practical skills that they learned on the job, such as painting signs or houses. Folk artists today continue to be everyday folk who use their acquired skills—and their imaginations—to create their unique works of art.

Because many folk artists have no formal art training, artistic rules such as perspective (drawing objects three-dimensionally in order to give them the illusion of depth and distance) and proportion (drawing objects so that their size and shape are harmonious to one another) usually are not followed. Folk artists often use simple artistic techniques, bright colors, and childlike perspectives, creating art as a means of self-expression rather than creating art that's "correct." This untrained style can also be called "naïve art."

Folk art is truly art of the human spirit. It is continually produced by people of all walks of life and from all over the world. As long as there are people with a need to imagine and create, folk art will always be around.

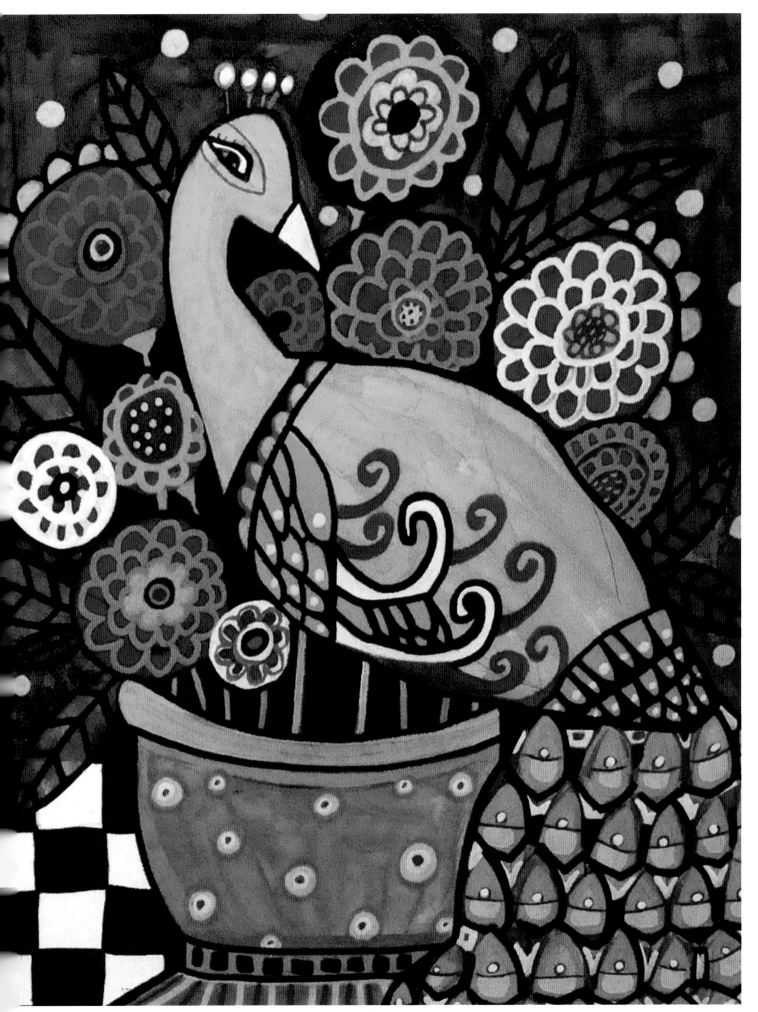

Tools & Materials

Here are the tools and materials you will need to
complete the paintings in this book.

PAPER

Paper comes in various weights and sizes. I like to use 80-lb. paper because the paper holds its shape when painting. Thin paper warps when it gets too wet; generally, the heavier the paper, the easier it will be to paint. You can use paper in sizes 8½" x 11" and 11" x 17".

PAINTS

Paints should always be the best quality you can afford. There are two types of paint you can use for the projects in this book: acrylic paint and craft paint. Acrylic paint will produce a good pigment with a deep intensity. Craft paint is a less expensive option, but it doesn't contain as much pigment as acrylic. You might need more layers of paint to get the color and intensity that you want.

PAINT PENS

Paint pens—also known as paint markers—come in a variety of colors and types, but we will be using oil-based paint pens. I like to use oil-based paint pens because they add a glossy finish on top of the flat paint, which lends a bit more depth and interest to a painting. You can usually find paint pens in the glass paint section of any craft store.

BRUSHES

Paintbrushes come in low, medium, or high quality, and they have either natural or synthetic hair. For the projects in this book, choose synthetic, medium-quality brushes. Low-quality brushes shed, and high-quality brushes are costly and unnecessary for these types of paintings. There are several types of brushes available, from flat to round and pointed to angled. A flat brush is a good all-purpose brush to use for the paintings in this book.

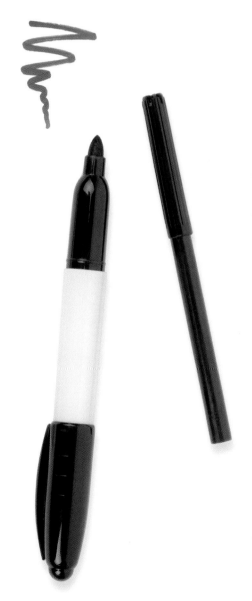

MARKERS

Black permanent markers are ideal for drawing the outlines of the art as well as for filling in larger areas instead of using paint or a paint pen. Choose markers with varying tip thicknesses, from fine to broad. I have found that cheap markers are just as good if not better than name-brand ones.

Painting Techniques

As you create your paintings, keep these tips and techniques in mind.

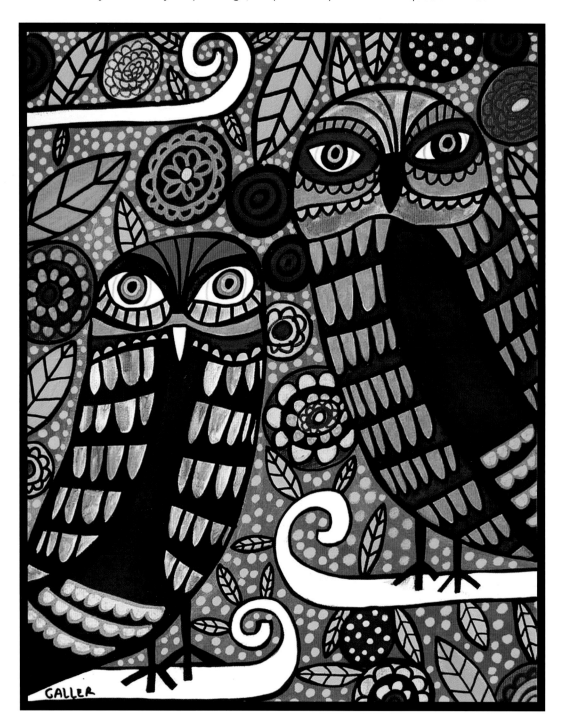

ADD LINES & DETAILS

My favorite technique for painting folk art is to use a black marker to clean up lines and draw details. I love the simplicity of a black marker against flat acrylic paint. Plus, when you draw your design, you can cover the black lines with paint and easily see through to your design. Then, after the paint is dry, you can redraw your lines with a black marker.

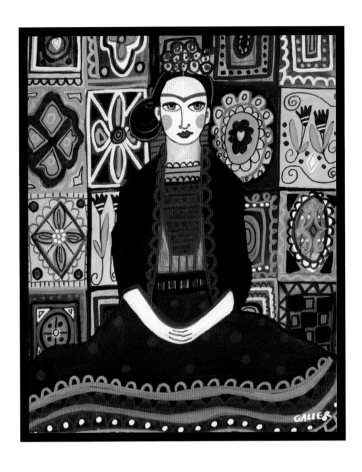

KEEP PAINT LAYERS THIN

When painting on paper, it's a good idea to use thin layers of paint. You can add more layers after each layer dries to darken the color, or use other colors to add designs and elements to the painting.

COMPLETE THE PAINTING

Folk art often includes lots of patterns, and oil paint pens are my favorite tools for adding details as a finishing touch. Paint pens come in both acrylic and oil; I prefer oil pens because I like that glossy finish against the flat acrylic paint, and they add an unexpected depth to the design.

Paint pens come in a limited selection of colors. To broaden the color variety, use a light coat of acrylic paint over the paint pen color to achieve different colors. This technique will dull the shine of the paint pen color, but sometimes it's worth it. Make sure to let the paint pen color dry for at least one hour or until the paint no longer feels tacky.

Naïve Style

Naïve style is quite childlike in its simplicity. It can be difficult to teach someone this type of artistic style because it is a very intuitive and personal process. Thus, most folk artists who use a naïve style are self-taught. The key to painting in a naïve style is to just let go. Don't try to make it look "right" or realistic.

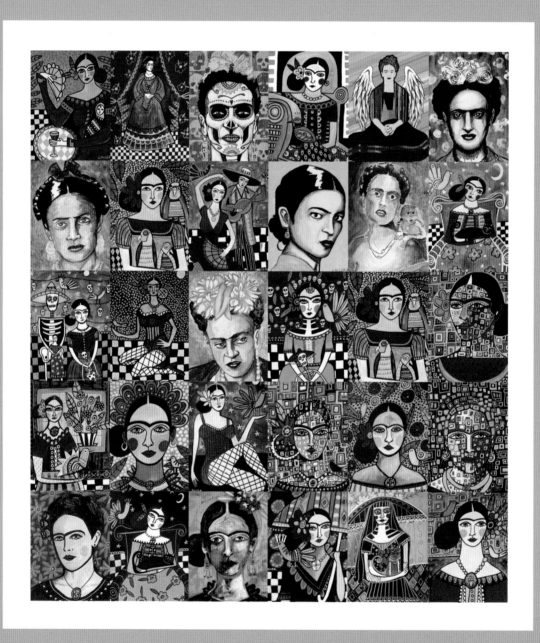

DRAWING EXERCISE

Now try flexing your naïve-style muscles.

STEP 1

First, get inspired. Choose a part of the world that piques your interest, and research the culture, history, and traditions of the people there. Start a folder on your computer to save inspirational pictures, or use a bookmarking website to build your vision.

STEP 2

Next, get a stack of white paper or card stock and a black permanent marker, and start sketching your idea. You can use a pencil and an eraser, but I encourage you to graduate from pencil to marker because it will force you to draw with confidence.

STEP 3

Keep drawing your ideas and visions. At first you might feel nervous, but that's the point. You want to push yourself out of your comfort zone. As you are drawing and creating, keep these tips in mind.

• Don't try to draw in a childlike way or how you think a naïve style should look. Only draw what you envision.

• Remember that every artistic effort is good, so don't judge your drawings negatively. "Bad" artwork is simply not possible in naïve art. Anyone who steps into the artistic arena is automatically qualified.

• Draw, draw, and draw some more. Draw so much that you have stacks and stacks of paper lying around. This is the only way you will get to know your natural artistic voice.

Color Choices

How do you choose the right colors for your paintings when there are so many to choose from? Here's what I do.

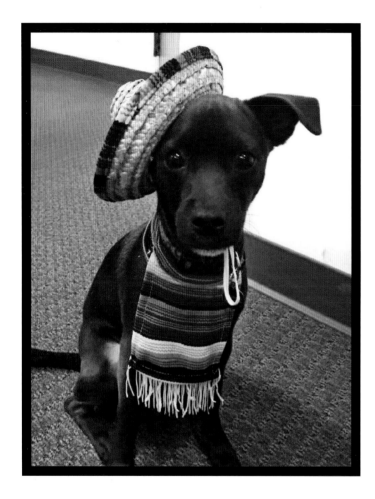

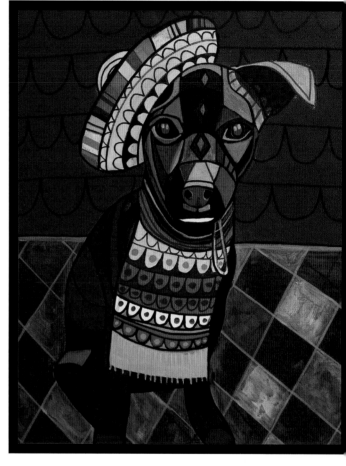

IDENTIFY AN INSPIRATION SOURCE

I'm inspired by a Chihuahua from San Francisco, who's dressed in a Mexican fiesta hat and serape. I chose this picture because I love dogs and I love the Mexican culture. The dog's expression and stance are ideal for painting.

CREATE A COLOR PALETTE

Use color inspiration from the actual image as well as your own artistic intuition. Color evokes different emotions—choose colors that you are excited to use. Yes, the colors you choose should excite and inspire you. When choosing a color palette, start by selecting the background colors first, and then build from there. Each project in this book includes a sample color palette that you may want to reference in your own paintings.

• Frida Kahlo •

Now it's time to create your own art, starting with a very popular subject in folk art: Frida Kahlo. One of Mexico's most famous artists, Frida Kahlo (1907-1954) achieved great international popularity during her short lifetime. She is best known for her frank and revealing self-portraits, many of which include her beloved pets.

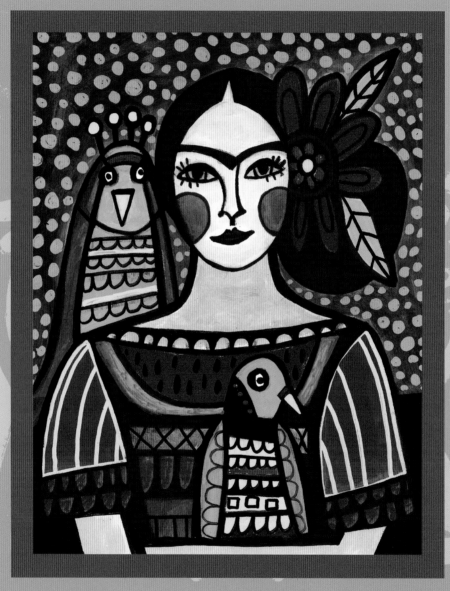

STEP 1

With a fine-tip black marker, copy the Frida Kahlo template onto a sheet of paper. Fill in the large black areas with a broad-tip black marker. Alternatively, you can use a small, flat brush to fill in the large areas with black paint.

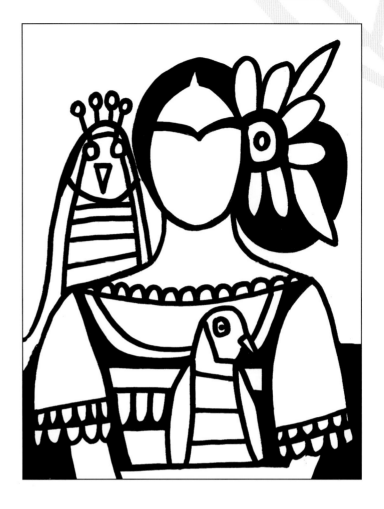

STEP 2

Using a medium, flat brush, apply a thin coat of green paint to the background. Let the coat dry, and then apply a second thin coat of green paint. You're trying to create a dark-green background, so depending on the type of paint you're using, you might even need three thin coats. Next, use a medium, flat brush to paint Frida's sleeves and shirt a dark orange-red. Then use a small, flat brush to paint the inside of the flower in her hair the same orange color as the sleeves and shirt.

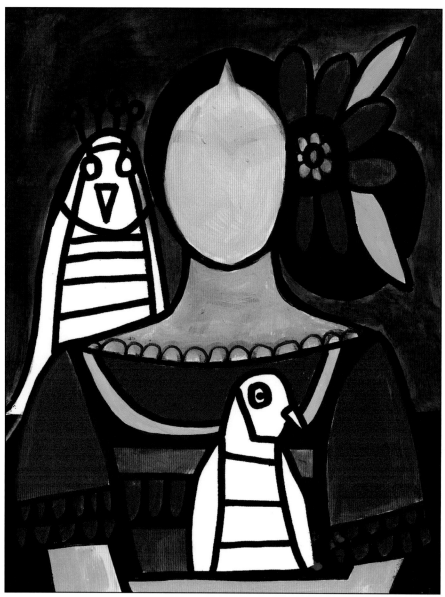

As your painting dries in between steps, go over the black lines with a marker to keep the lines looking sharp.

STEP 3

Wet a small, flat brush with water, dip it in magenta paint, and color the shirt ruffles and flower petals. You're looking for a light, translucent coat of magenta; the wet brush helps thin the color a little. Next add a pinch of magenta to some white paint to create a pinkish hue, and paint the face, neck, and arms with a medium, flat brush. It's OK to paint over the eyebrows at this point, because you'll paint them back in during step 6. Using a small, flat brush, paint the watermelon flesh—which sits below her neck and above the bodice of her dress—red. Paint the watermelon rind and flower leaves green.

STEP 4

With a small, flat brush, paint the birds using teal, turquoise green, ultramarine blue with a pinch of white, and yellow. Let the birds dry, and then add details to their bodies with a medium-tip black marker. Now use an orange oil-based paint pen to add line details to the sleeves. When that is dry, use a medium-tip black marker to add details to the flower petals and leaves in Frida's hair. Now paint black seeds on the watermelon, and add details to the bodice of the dress.

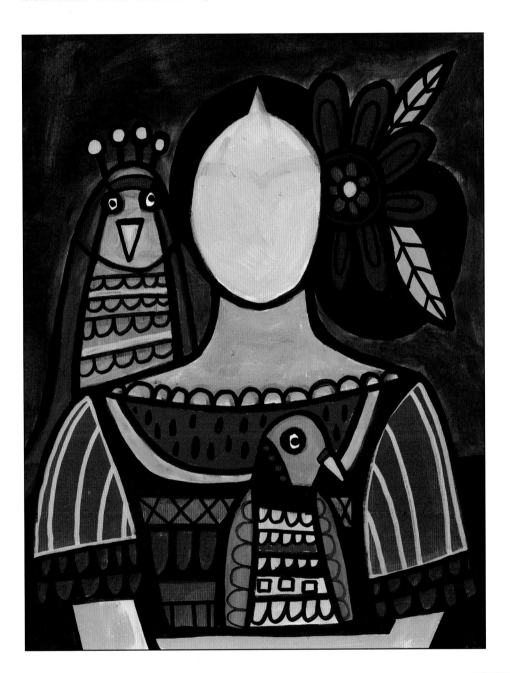

STEP 5

Now you'll focus on adding detail to the background. Using a baby-blue, oil-based paint pen, start from the top left of the page, and paint circles randomly over the green background. Let this dry for at least an hour.

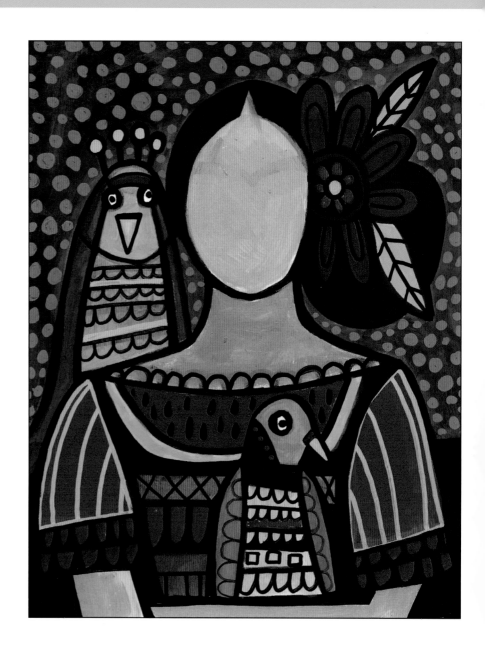

If you make a mistake on the face, use a coat of white paint as an eraser, and try again.

STEP 6

Draw in Frida's face using fine-tip and medium-tip black markers. Fill in her unibrow, and add a black line to separate the watermelon and her chest. Paint her lips using a red paint pen, and then carefully outline them using a fine-tip black marker. Fill in the irises of her eyes using a blue paint pen. Paint her cheeks pink, and then outline them using a red paint pen. If you notice any lines that might need to be cleaned up, go over them with a black marker or black paint pen.

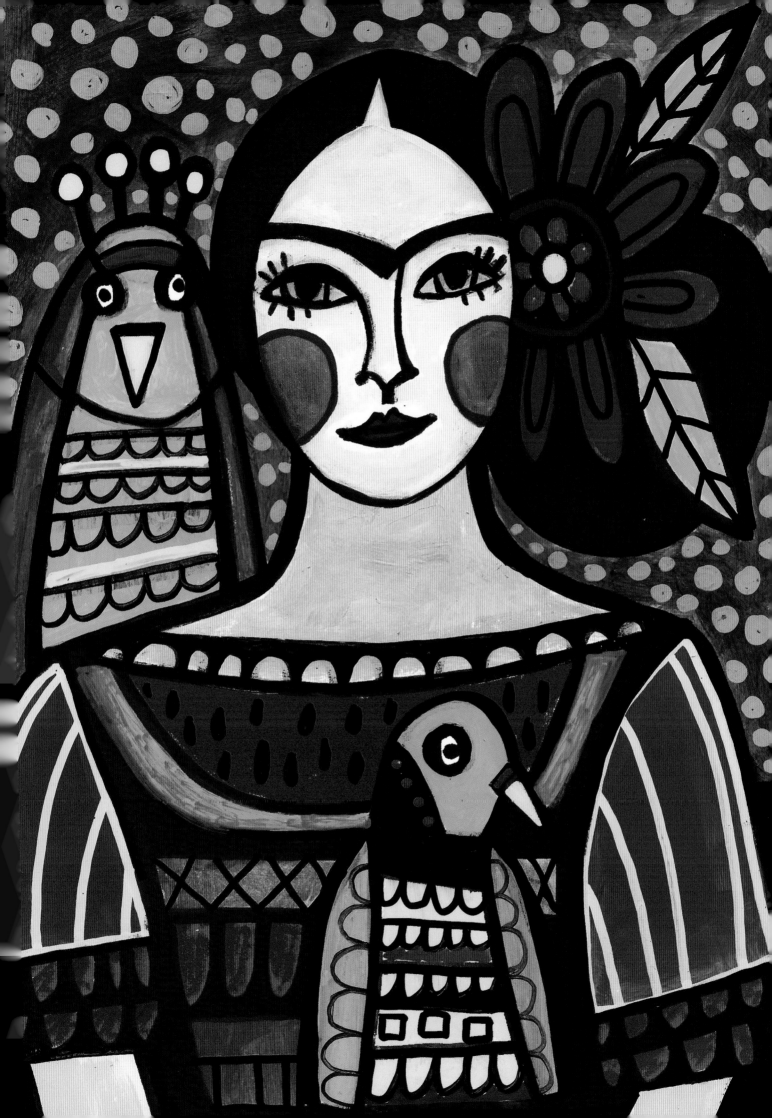

• Day of the Dead •

Day of the Dead, also known as *Día de los Muertos*, is a Mexican holiday that is all about remembering and praying for loved ones who have passed away.

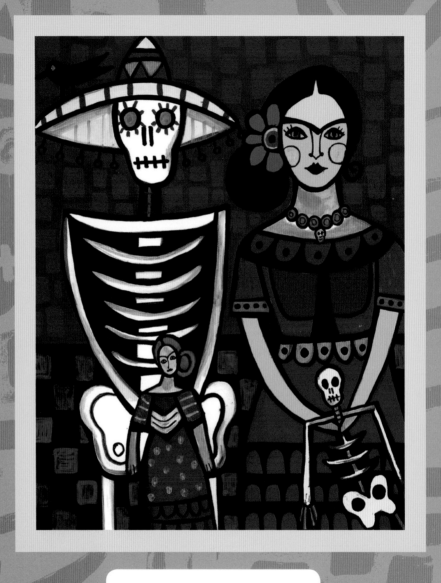

STEP 1

With a fine-tip black marker, copy the Day of the Dead template onto a sheet of paper.

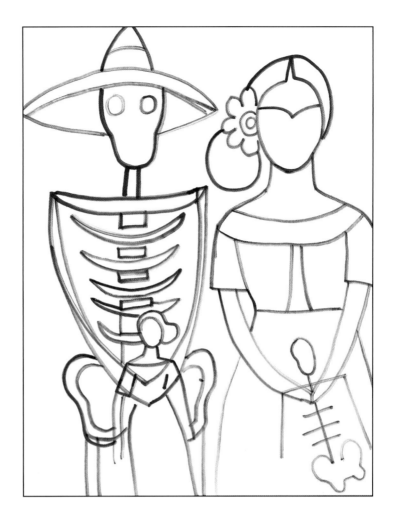

STEP 2

Using a medium, flat brush, fill in the bottom half of the background and the woman's hair with black acrylic paint. Alternatively, fill in the areas with a broad-tip black marker. Paint the top half of the background bright red with a medium, flat brush. You want rich color, so apply two or three coats of each color, letting each coat dry before adding another layer of paint.

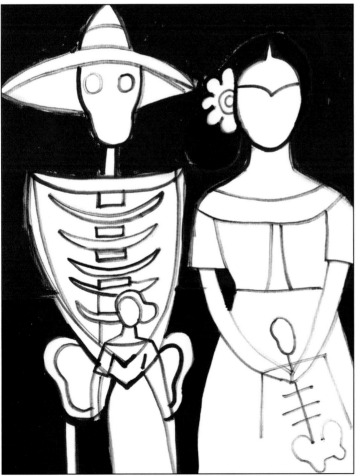

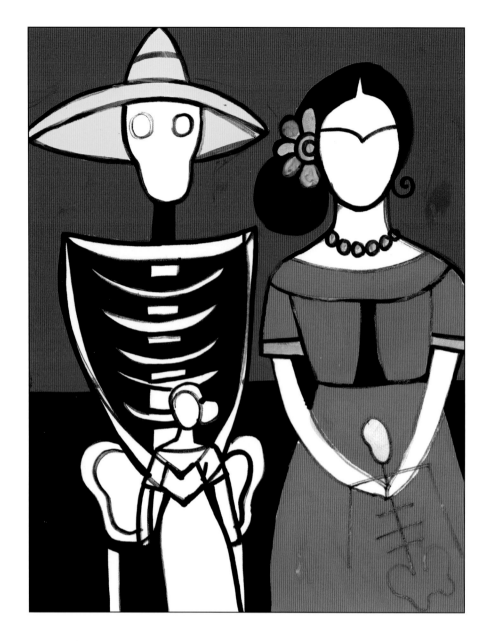

STEP 3

With a small, flat brush, paint the woman's dress bright pink. Use another small, flat brush and turquoise paint to add color to the sleeve cuffs on the woman's dress, the flower in her hair, and her necklace. Paint the skeleton's hat bright yellow using a small, flat brush. With a medium-tip black marker, fill in the area around the skeleton's chest.

STEP 4

With a small, flat brush, paint the doll's hair turquoise. Use another small, flat
brush to paint the doll's dress red. With a baby-blue paint pen, create small
squares on the black background. Use the same pen to fill in the skeleton's eyes.
Let the painting dry for at least an hour until it's no longer tacky to the touch.

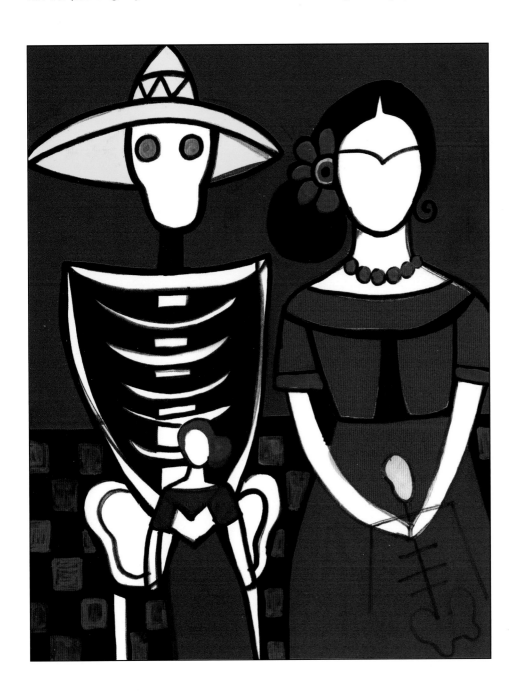

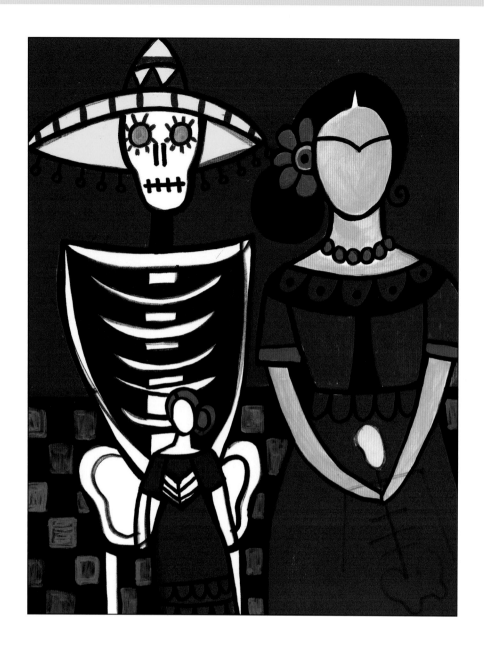

STEP 5

Use a fine-tip black marker to draw details on the doll's dress and hair as well as the woman's dress and the skeleton's hat. Paint the woman's skin pale pink using a small brush. Use a red marker to add details to the skeleton's hat and eyes.

STEP 6

Using an orange paint pen, add randomly placed squares to the red background. With a pink paint pen, color the triangles in the hat and the polka dots on the doll's dress. Add eyes, cheeks, a nose, and a mouth to the woman's and to the doll's face with a fine-tip black marker. Use a green paint pen to add color to the woman's eyes. Use the pink paint pen to fill in the woman's cheeks. Draw the skeleton doll's bones with a white paint pen, and then outline the bones and add details to the face with a fine-tip black marker. With a medium-tip black marker, add details to the woman's dress, and fill in the trim. Finally, draw a black crow on top of the skeleton's hat with a medium-tip black marker.

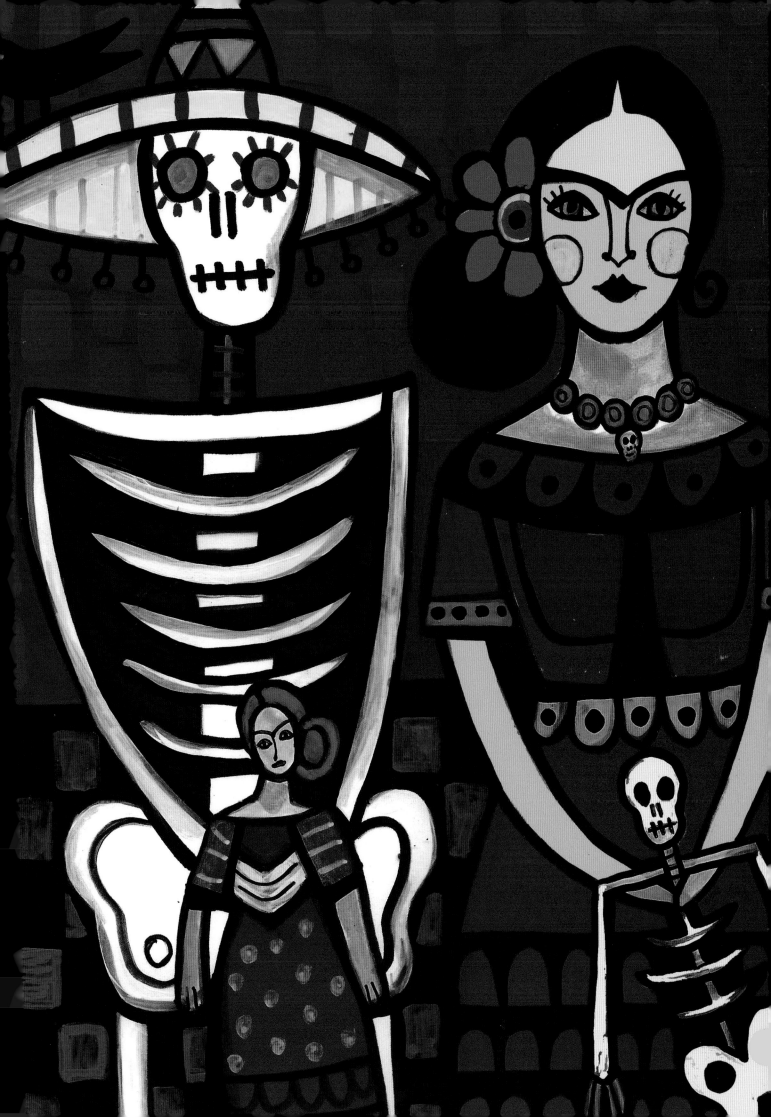

Our Lady of Guadalupe

Our Lady of Guadalupe—also known as the Virgin of Guadalupe—is a title for the Virgin Mary, the mother of Jesus according to the New Testament of the Christian Bible. An image of the Virgin of Guadalupe is enshrined in the Basilica of Our Lady of Guadalupe, a Roman Catholic church in Mexico City, which is one of the world's most-visited sacred sites.

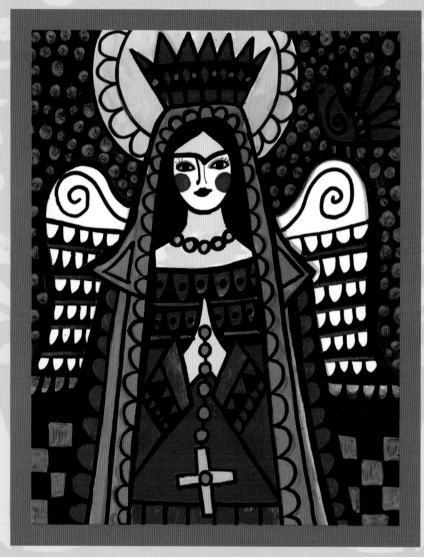

STEP 1

With a fine-tip black marker, copy the template onto a sheet of paper.

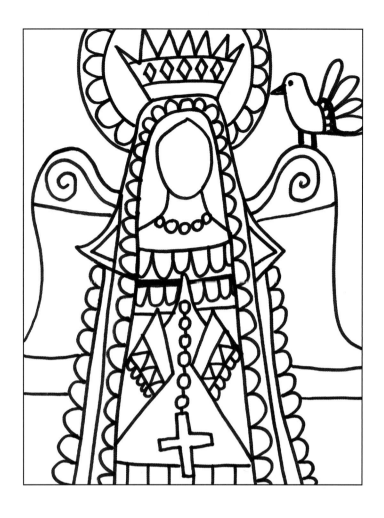

STEP 2

Using small and medium flat brushes and black paint, fill in the Virgin's hair and the bottom area of the background. Use a black permanent marker to fill in the more detailed areas, such as the crown, wings, the bodice of her dress, and the sleeves.

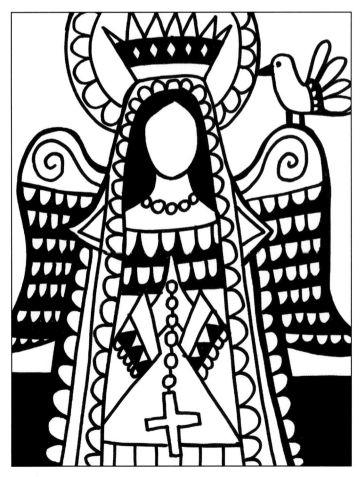

STEP 3

Paint the halo, necklace, and cross bright yellow with a small, flat brush. With a medium, flat brush, paint the background purple. You want the background to be a deep, dark color, so you will need to use several layers of paint. Let each layer dry before adding a new layer of paint.

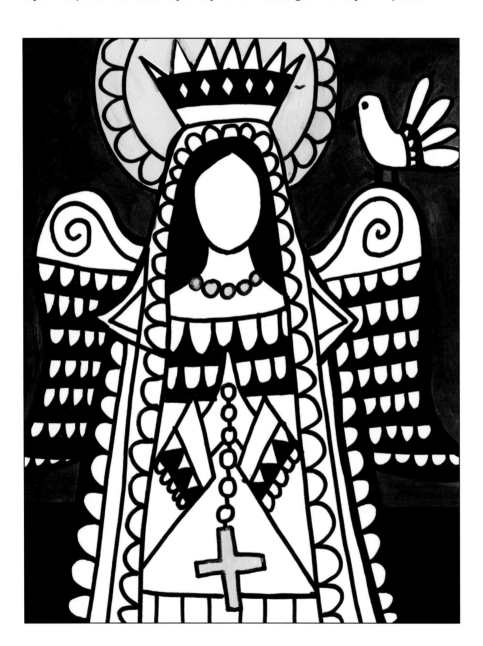

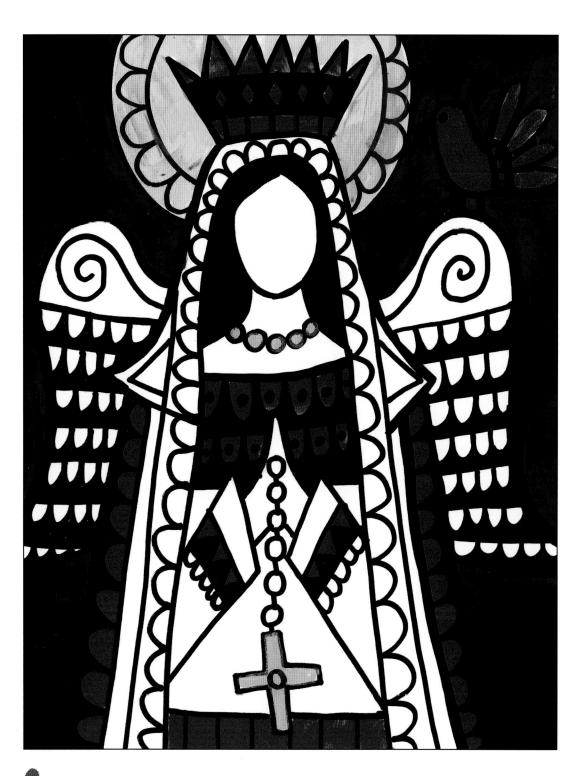

STEP 4

With a small, flat brush, paint the outer frills of the robe and sleeve details magenta. Use bright orange to paint the crown, bird, and dress details.

STEP 5

Use yellow, hot-pink, and bright-red paint to color the dress, and then paint the robe teal. Paint the inner frills of the robe and the cross chain with a green paint pen, and then add green squares to the background near the bottom of the page.

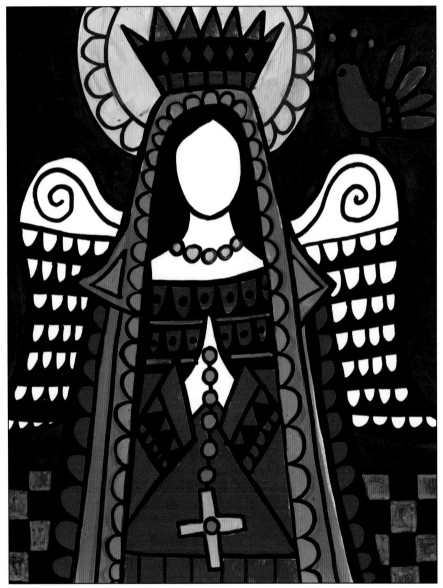

STEP 6

Create the dot effect in the background with a lilac paint pen, and then add lilac details to the wings. Draw the Virgin's face with a black permanent marker, and then use pale pink to paint her forehead, neck, and chest. Add rosy cheeks with a hot-pink paint pen.

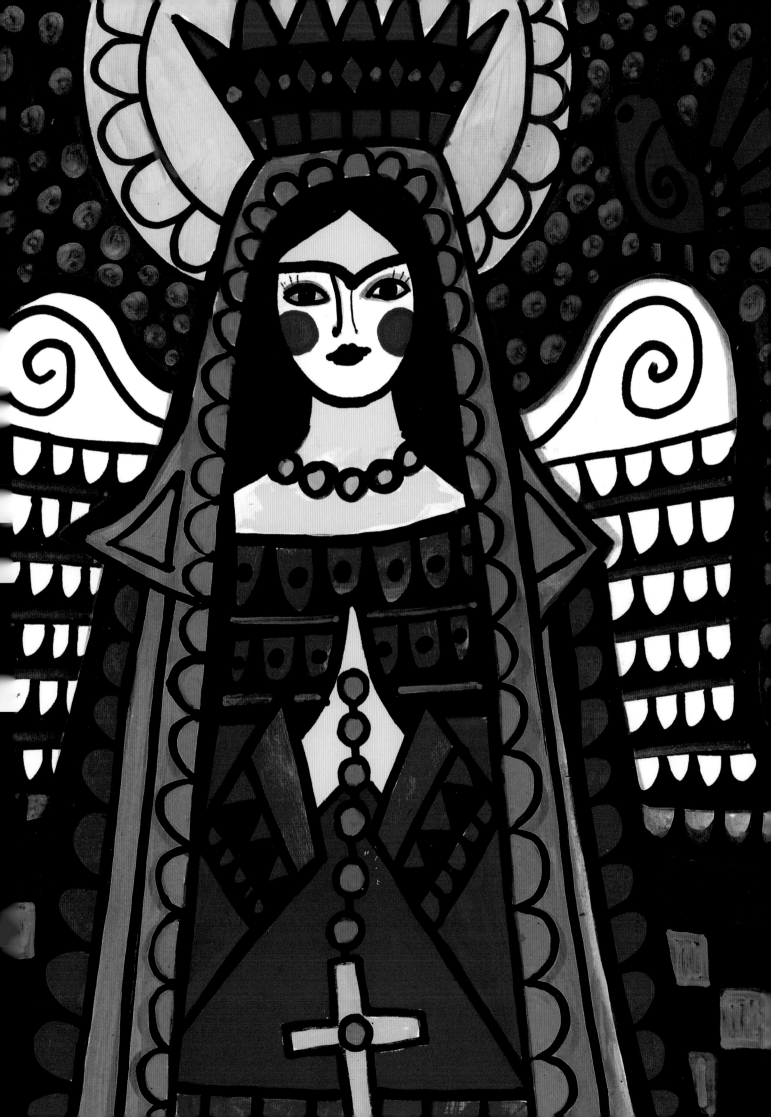

• Tree of Life •

The Tree of Life is an intricate Mexican clay sculpture that traditionally depicts biblical stories, such as Adam and Eve in the garden of Eden. Today, the concept of a Tree of Life can represent all kinds of different images, not just biblical ones.

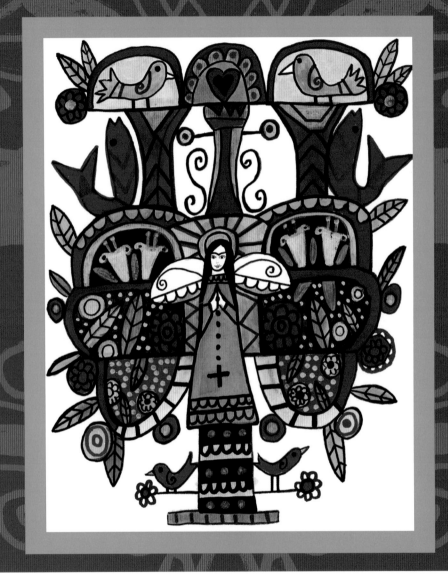

STEP 1

With a fine-tip black marker, copy the template onto a sheet of paper.

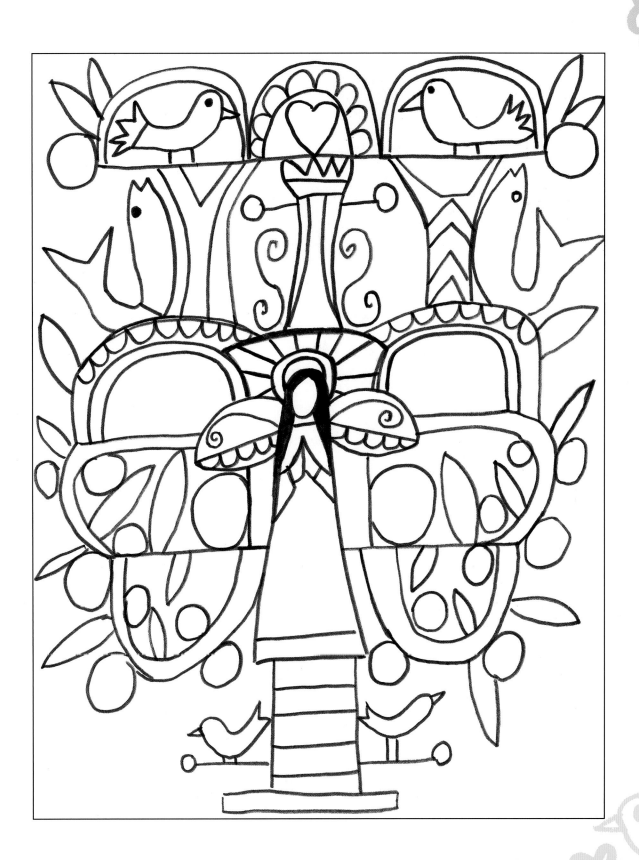

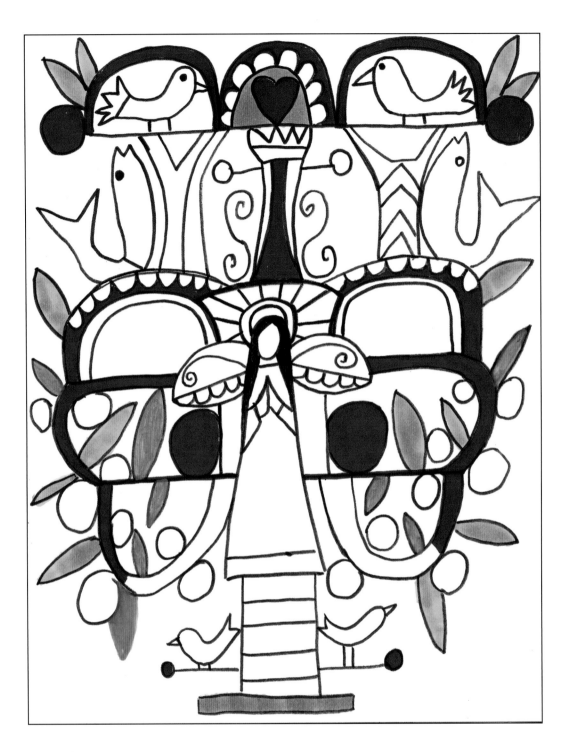

STEP 2

Using a small, flat brush and red paint, fill in the curves of the tree, the two circles on either side of the angel, the two circles at the top of the tree, and the heart. Fill in the leaves, the base of the tree, and the area around the heart with green paint.

STEP 3

With magenta and light-pink paint, use a small, flat brush to fill in the fish at the top, the birds at the bottom, and the other red and magenta details on the tree.

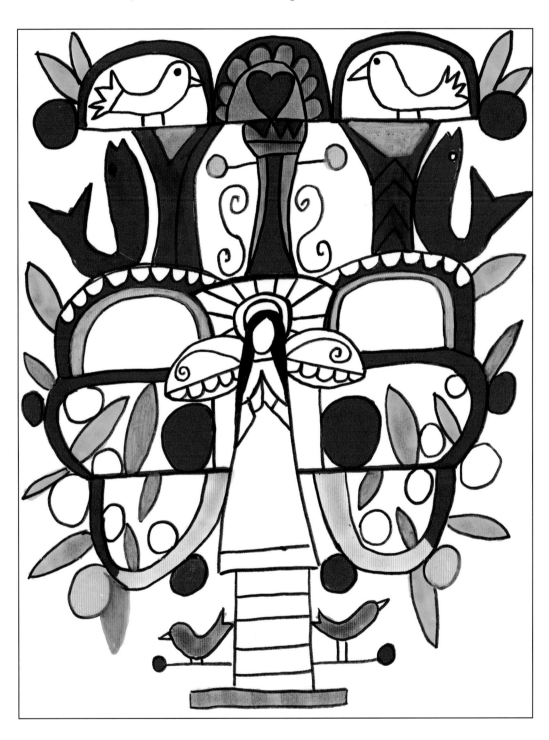

STEP 4

Fill in the birds at the top, two of the circles, and the area behind the angel with light-blue paint. Using a black permanent marker, add details to the trunk of the tree, and then fill in the trunk area and the semi-circles by the angel with black paint.

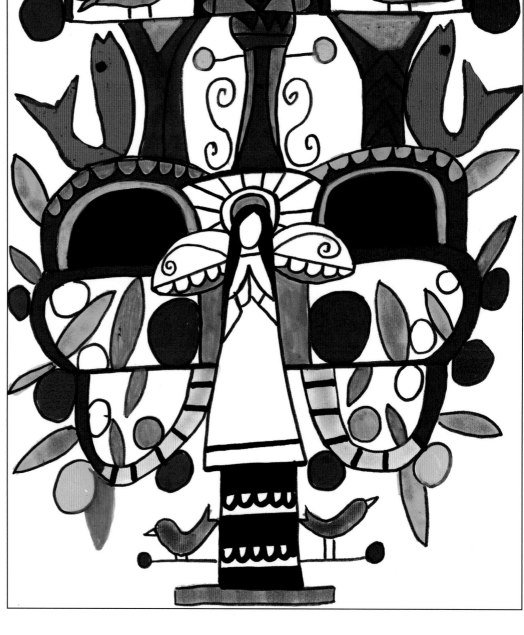

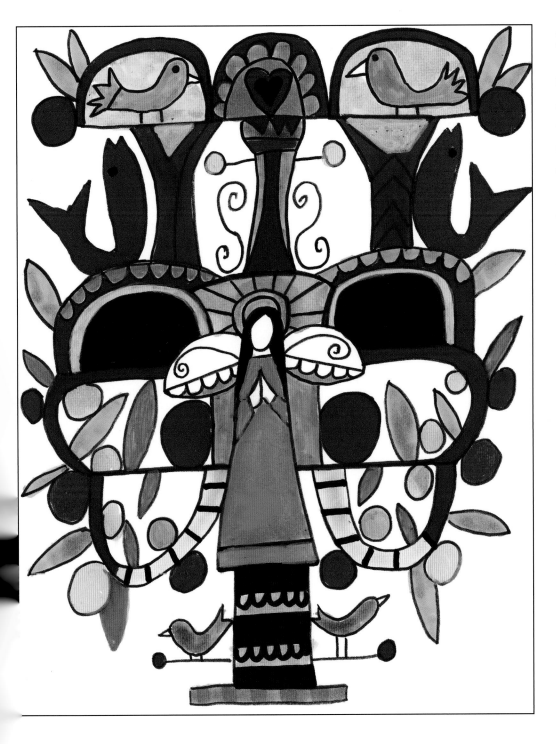

STEP 5

Using a small, flat brush and yellow paint, fill in the areas behind the two blue birds, the area above the angel's head, and the remaining circles on the tree. Using a small, flat brush, paint the angel's dress teal.

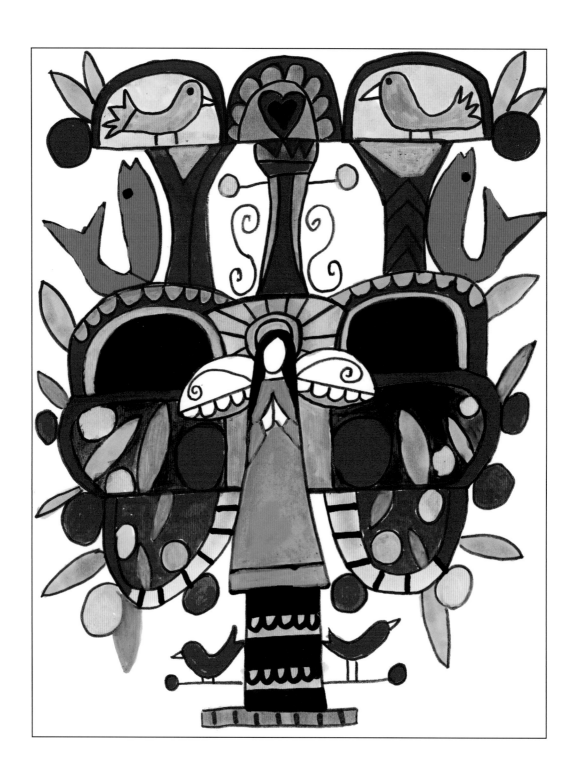

STEP 6

Using a small, flat brush, fill in the center parts of the trees with bright-blue and bright-red paints.

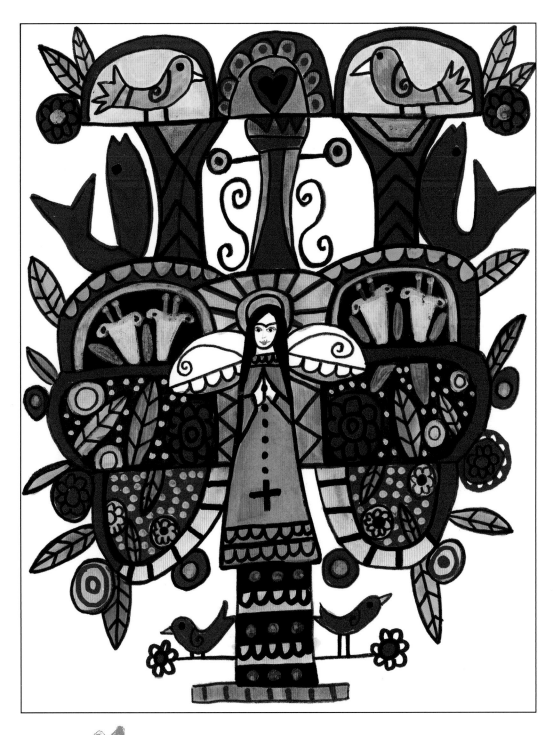

STEP 7

Add details to the flowers, leaves, and the angel's dress with blue, red, black, and orange fine-tip permanent markers. Using yellow and green paint pens, draw four calla lilies onto the black semi-circles on the tree. Add dots and details to the background with a yellow paint pen.

If the paint from the oil-based pen pools, use a cotton swab to soak up the excess paint.

• Ganesha •

Ganesha is one of Hinduism's most popular deities: He is honored when ceremonies and ritual begin as well before embarking on a new endeavor. Believed by Hindus to be the "remover of obstacles," Ganesha is often depicted with an elephant head, big belly, and multiple hands.

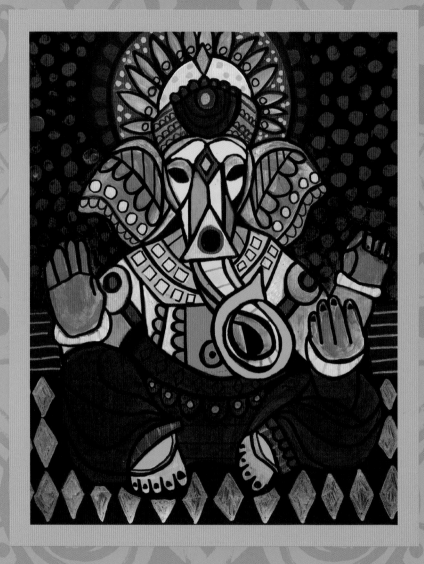

STEP 1

With a fine-tip black marker, copy the Ganesha template onto a sheet of paper.

STEP 2

Paint the bottom third of the background black with a medium, flat brush. Paint the remaining background purple with the same type of brush. Let the paint dry completely.

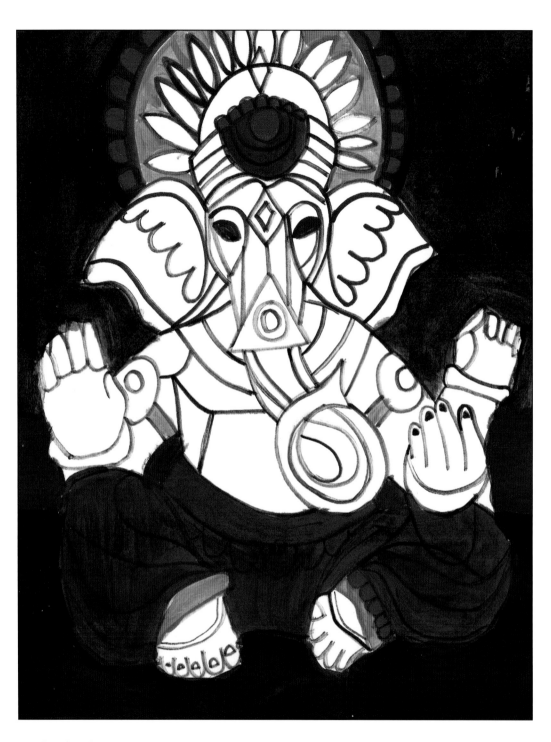

STEP 3

With a small, flat brush, paint a red band in the background between the purple and black. Depending on the type of paint you're using, you might need to use three coats of red paint to get the desired brightness. Use a small, flat brush and magenta paint to fill in the pants and headdress details. Use an orange paint pen to color the cuffs on the bottom of the pants as well as the background behind the headdress.

STEP 4

Now add gold details to the painting. Using a gold metallic paint pen, add diamonds to the black part of the background and thin lines to the red part. Continue using the gold metallic paint pen to add details to the sandals, arm bands, ears, and headdress.

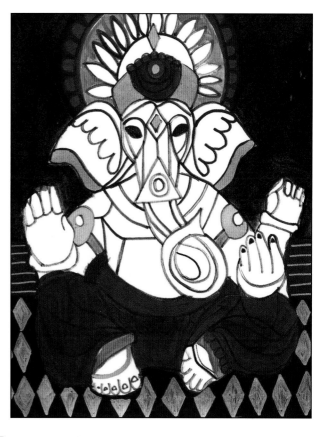

STEP 5

Use a small, flat brush to paint the body and headdress details teal. With a yellow paint pen, fill in the rest of the headdress, the triangle on the nose, and the bands around the wrists. With an orange paint pen, color the diamond on the nose, and fill in the circles on the arm bands. With a fine-tip black marker, color the nails on the toes.

STEP 6

With a light-purple paint pen, draw randomly sized polka dots on the purple background. With a green paint pen, add dots to the yellow part of the headdress. With a small, flat brush, paint the two rows on the chest green, and then let the painting dry completely. Once it's dry, use a yellow paint pen to add squares on top of the green rows. With a fine-tip black marker, add details to the belly. Use the same pen to sharpen the lines of the feet and pants.

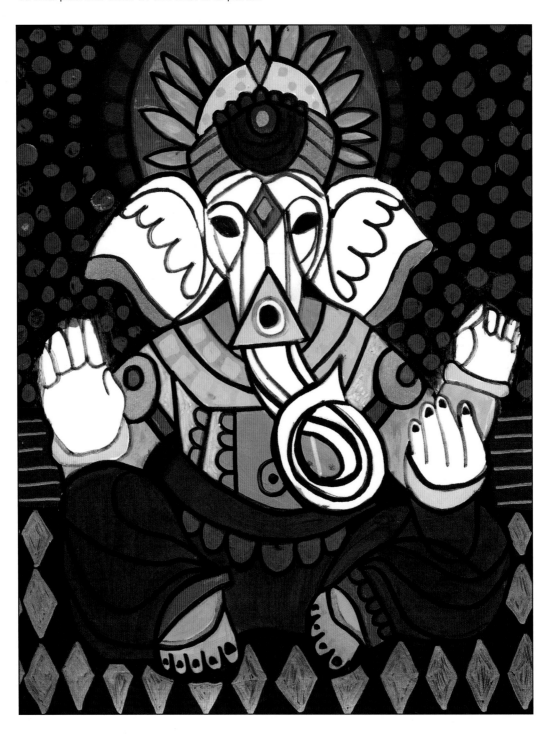

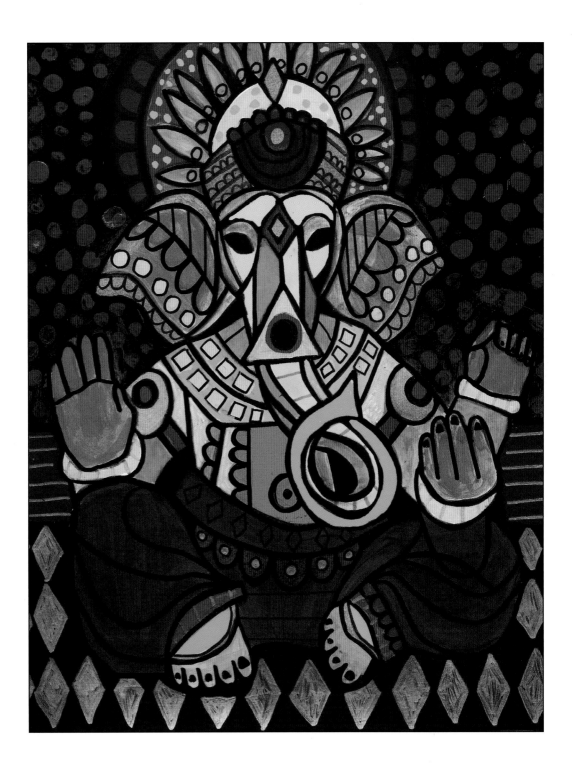

STEP 7

Paint the trunk using yellow and green paint pens. Use the green paint pen to add details to the headdress, and use the yellow paint pen to add details to the ears. Let the paint dry for at least an hour. Once it's dry, paint the ears and hands lilac with a small, flat brush. Paint the remaining part of the head and body with teal paint. Use a fine-tip black marker to add details to the ears, outline the yellow dots, add lines to the inner ear area, and add details to the headdress.

Gautama Buddha

Buddhists recognize Gautama Buddha as an enlightened teacher who shared his insights to help end suffering. Believed to have been born in the sixth century BC, Gautama Buddha (also known as Siddhartha Gautama) was the founder of the Buddhist religion.

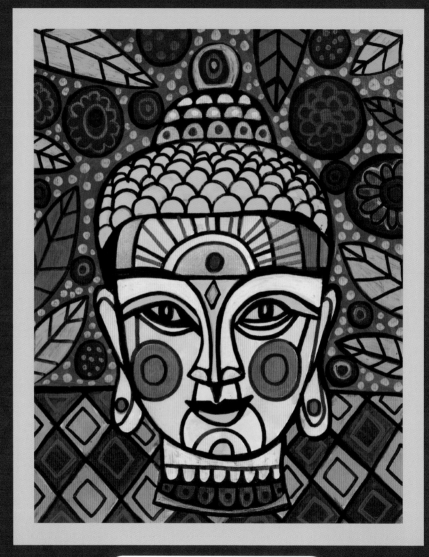

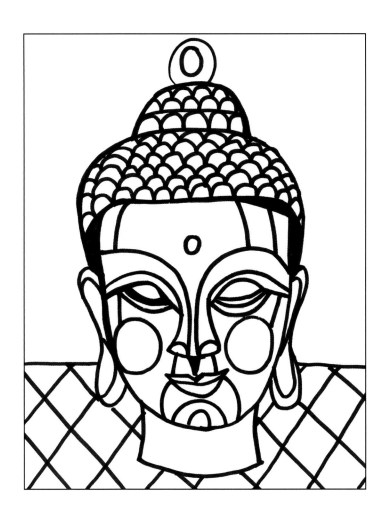

STEP 1

With a fine-tip black marker, copy the Buddha template onto a sheet of paper.

STEP 2

Using a large, flat brush, paint the top of the background aqua. Fill in the diamonds with blue and aqua paint using a small, flat brush.

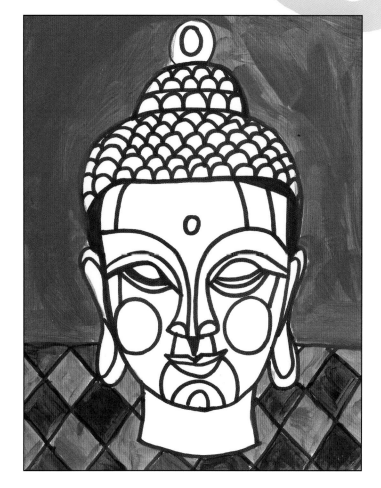

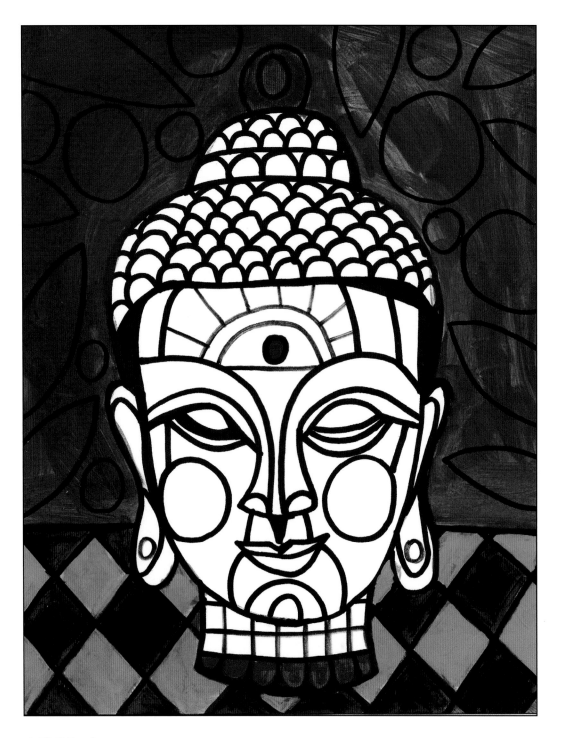

STEP 3

Sharpen the diamonds at the bottom by drawing over the lines with a medium-tip black marker. Then draw leaves and circles on top of the aqua background. Lastly, draw details on the forehead, ears, and neck. Paint the top of the head, the dot on the forehead, and the trim on the neck magenta using a small, flat brush.

STEP 4

Paint the circles in the background bright red and pink using a small, flat brush. Use the same brush to fill in the leaves with lighter and darker colors of green.

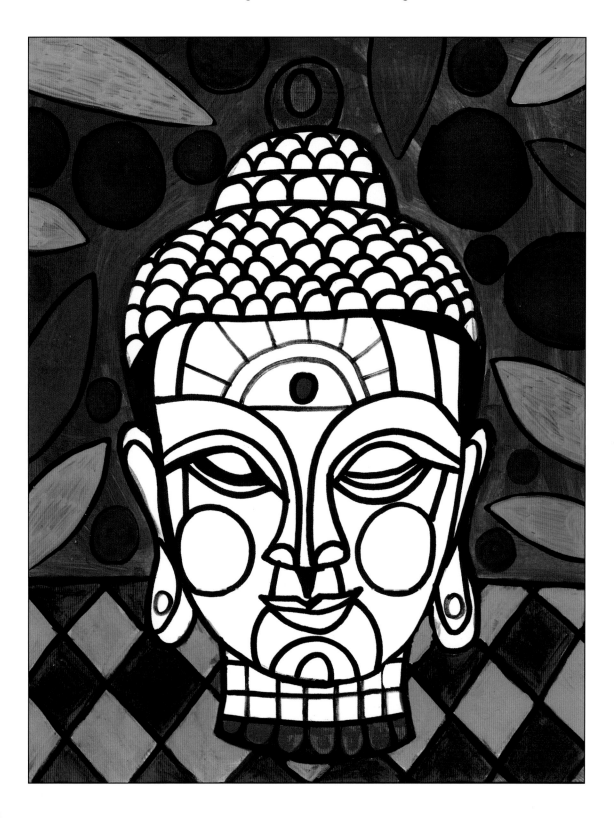

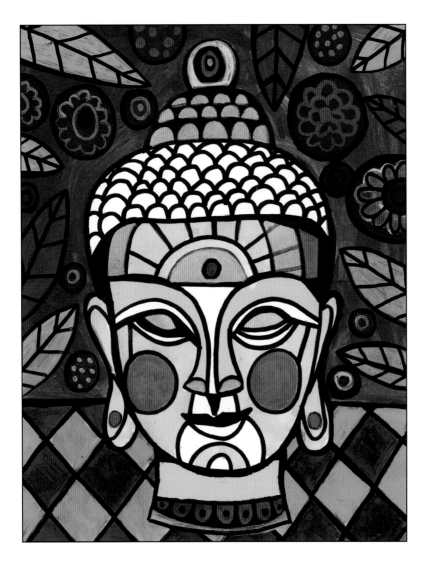

STEP 5

Add details to the leaves, and draw flowers on the circles with a fine-tip black marker. Add details to the flowers using orange and red paint pens. Using a small, flat brush, paint the Buddha's face and neck bright yellow, and use a gold metallic paint pen to fill in the details of the face. Using a small, flat brush, paint the cheeks orange.

Hone your paint-pen skills by drawing on paint swatches. You can find paint swatches in the painting section of a hardware store.

STEP 6

With a fine-tip black marker and a blue paint pen, draw diamonds inside the diamonds in the background. Using a small, flat brush, paint the eyelids and bottom lip robin's-egg blue. With the same color and a medium, flat brush, paint the remaining area on Buddha's head. Use a light yellow hue to paint the chin, under the eyes, and the upper lip area. Add small polka dots to the background with a baby-blue paint pen. Paint the nose light green, and let it dry. Once it's dry, draw a diamond between the eyes with a fine-tip black marker. Lastly, with a fine-tip black marker, draw the pupils of the eyes and the trim on the neck.

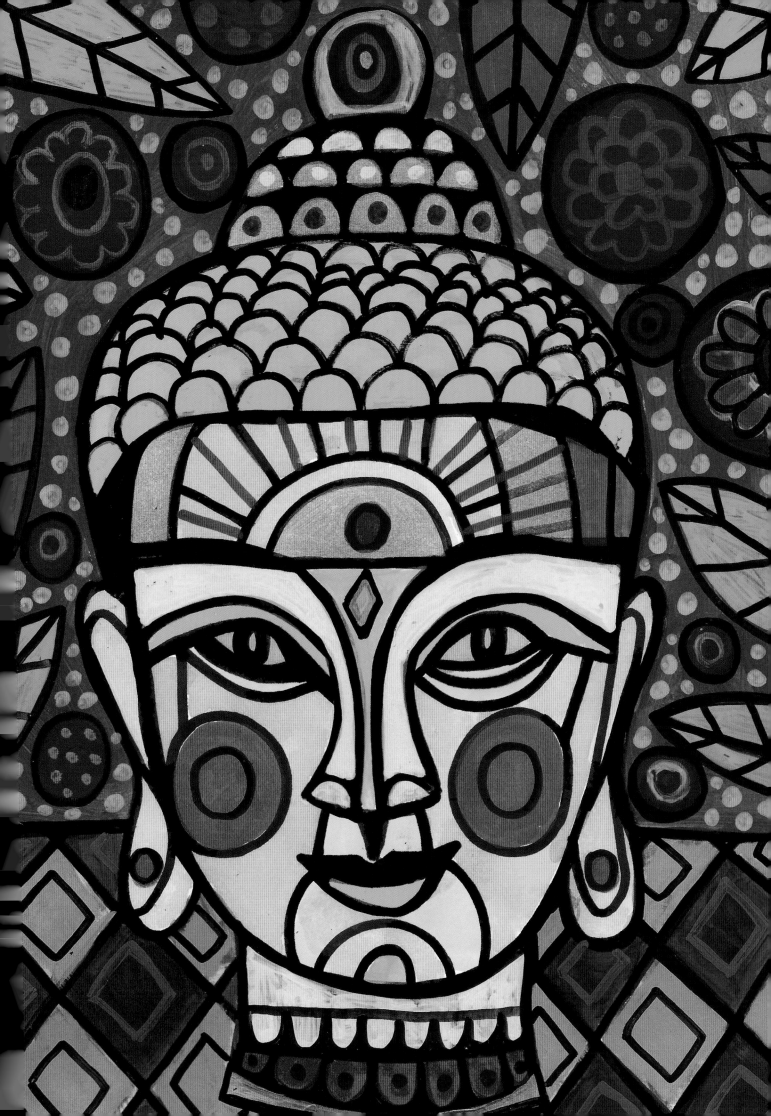

Chinese Dragon

Chinese dragons are mythical creatures that represent seasonal cycles, and they are believed to control rainfall, floods, and typhoons. The Chinese dragon is said to bring good fortune to those who are worthy.

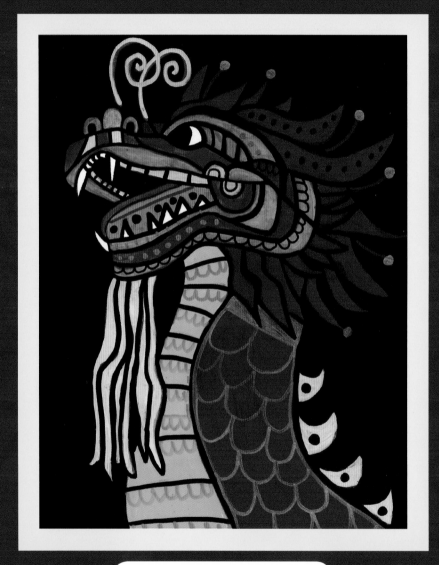

STEP 1

With a fine-tip black marker, copy the Chinese dragon template onto a sheet of paper.

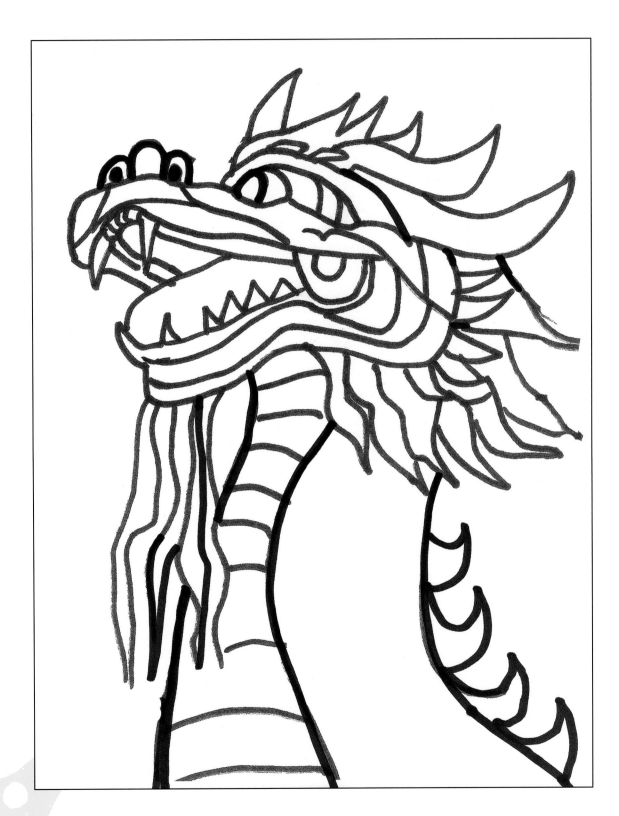

STEP 2

Using a medium, flat brush and black paint, fill in the background behind the dragon. Use fine- and medium-tip black markers to paint the more detailed areas.

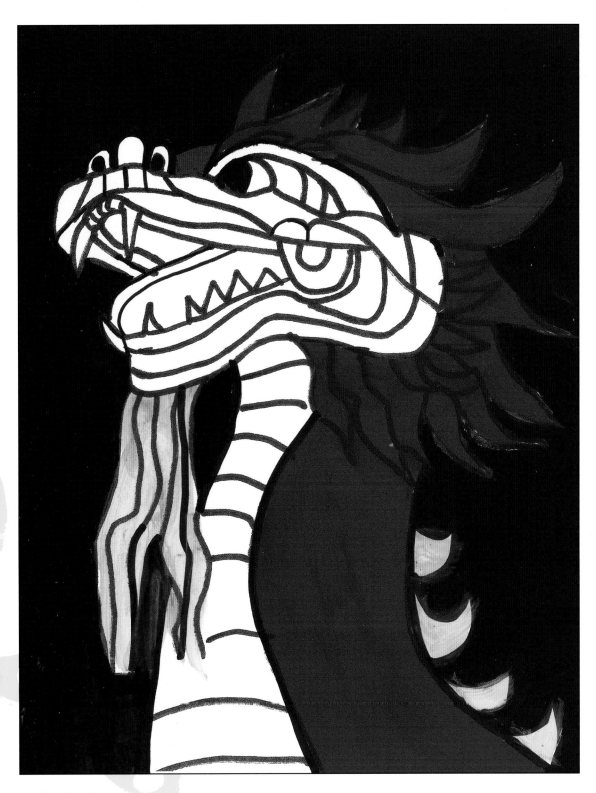

STEP 3

Paint the dragon's beard and the spines on its back yellow using a small, flat brush. With a medium, flat brush, paint the dragon's body red.

STEP 4

Now let's focus on the face. Use a small, flat brush to paint the face dark aqua and magenta. Use the same type of brush to paint the inside of the mouth pink. With a yellow paint pen, fill in the teeth and the cheek, and draw two curlicues above the nose.

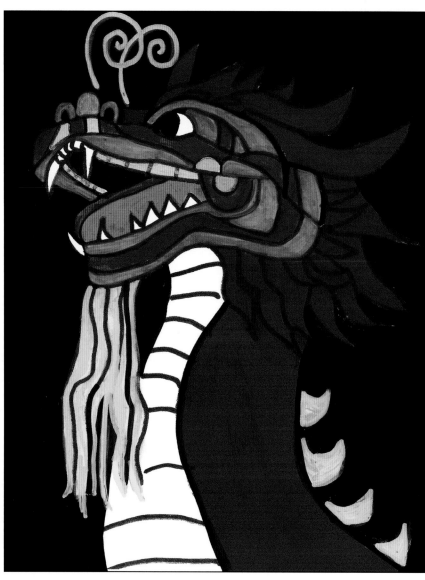

STEP 5

With aqua paint, fill in the dragon's chest area, and let it dry completely. When it's dry, use a green marker to add details to the chest. Use fine- and medium-tip black, red, and pink markers to draw dots on the tongue and on the spines on the back, and add details to the face. Use a metallic-gold paint pen to add details to the red part of the body as well as gold frills to the head.

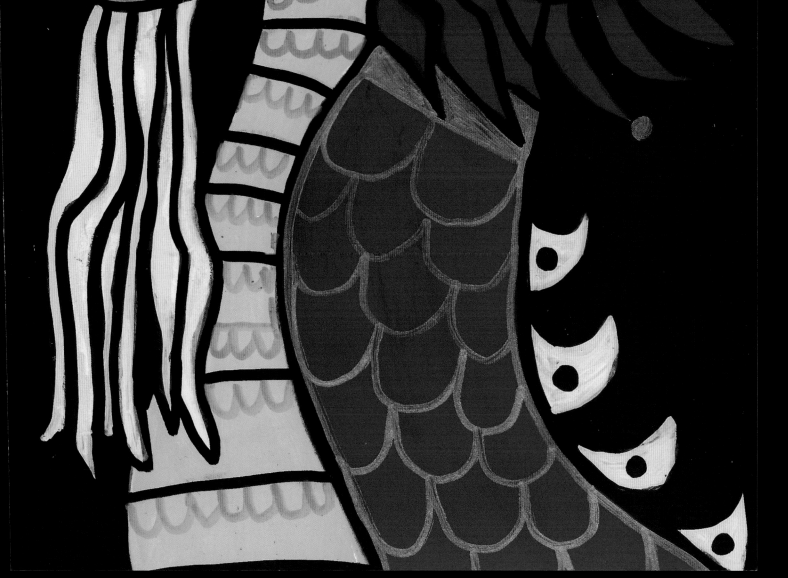

Maneki Neko

Maneki neko are Japanese talismans and are thought to bring good fortune and wealth to their owners. You often see these "beckoning cats" with one upright paw displayed in shop entrances, restaurants, and other businesses.

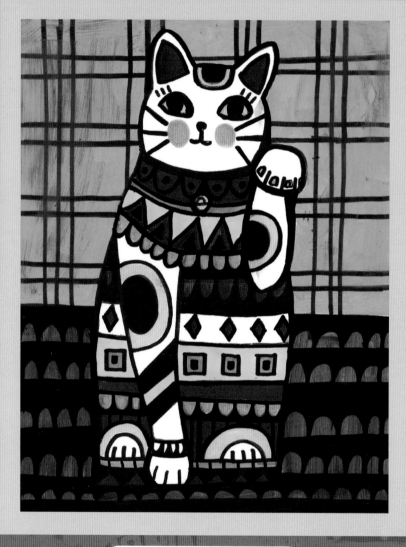

STEP 1

With a fine-tip black marker, copy the maneki neko template onto a sheet of paper.

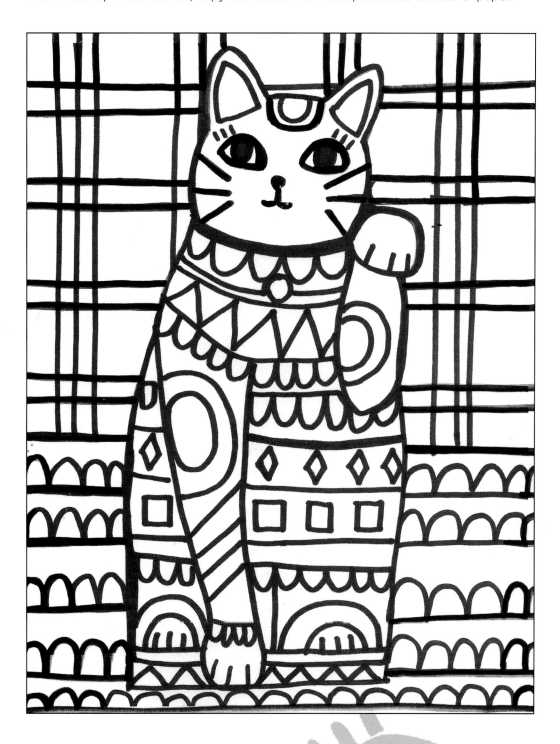

STEP 2

Using a medium, flat brush, paint the top half of the background light green and the bottom half dark green. It's OK to paint over the black lines—just be sure to use thin layers so that you can see the lines and details through the paint. Let the paint dry, and then go over the lines with a black permanent marker.

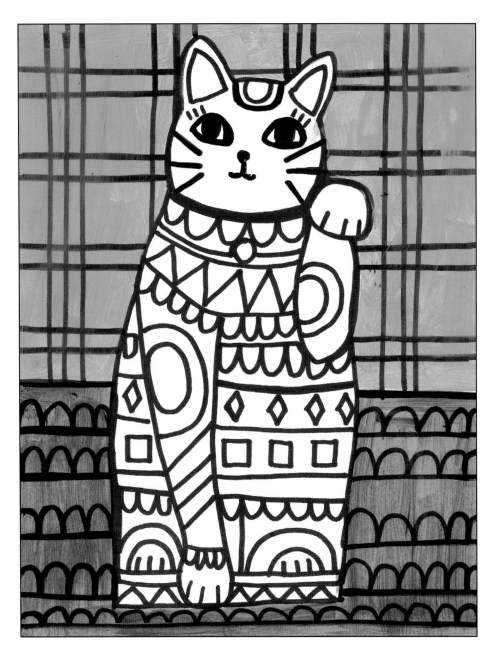

STEP 3

Using yellow and magenta paint pens, color in the cat's ears, eyes, and the shape details on the body. Fill in the black areas with a black permanent maker.

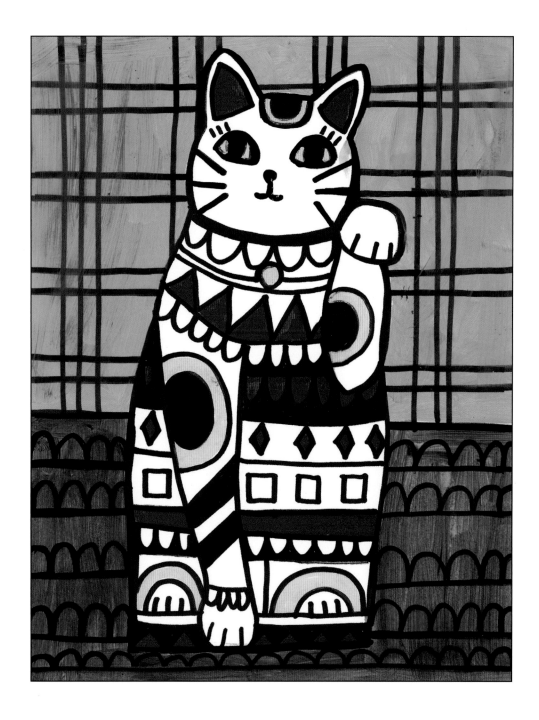

Paint pens are very versatile and great for more than just paper. You can use them for drawing on glass, wood, clay, porcelain, stone, metal, and mirrors.

STEP 4

With a small, flat brush, fill in the designs on the cat's neck and hind legs with bright-red paint. Use light-green and dark-green paint pens to fill in the square design details on the cat's body, the triangles below its collar, and the green line near the center of its body.

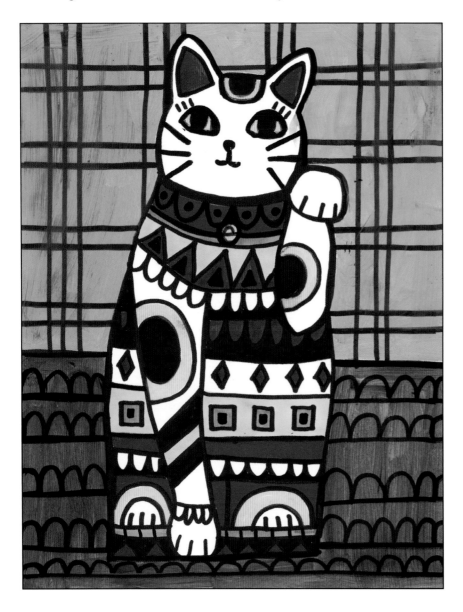

STEP 5

Focusing on the bottom half of the background, fill in the green rows with a black permanent marker. Using a lilac paint pen, fill in the details on the cat's body, paint round circles on its cheeks, and paint nails on its paws. Let the paint dry, and then go over the black lines with a black permanent marker.

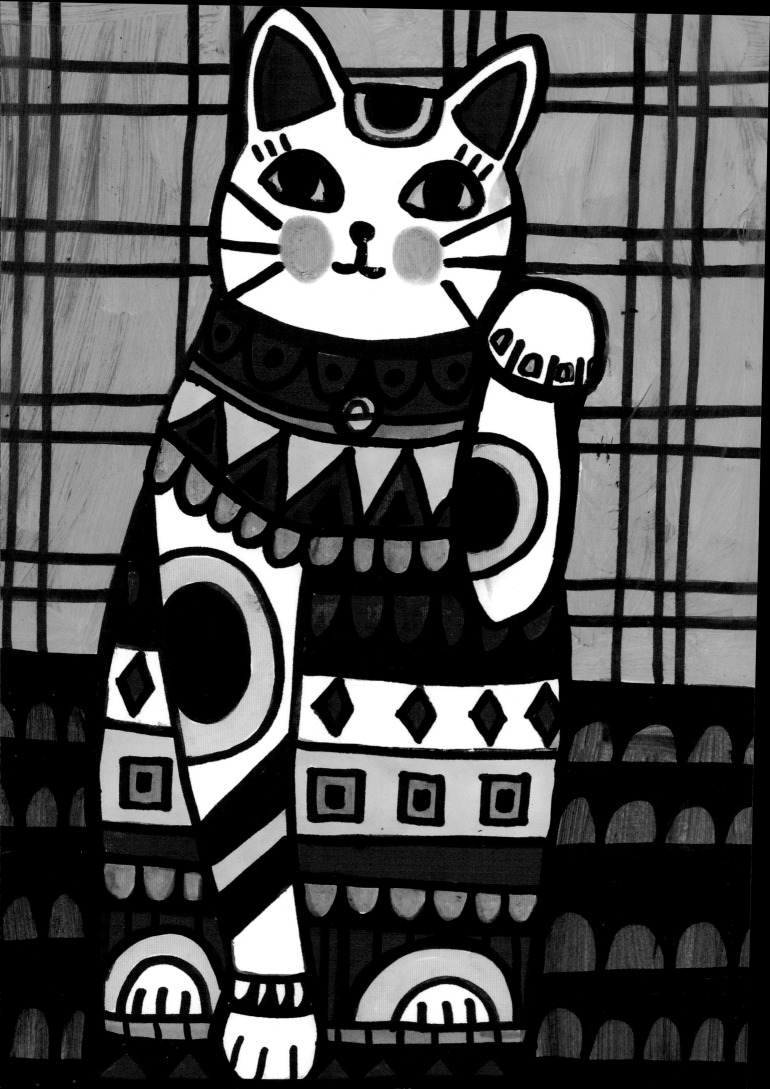

•Dutch Tulip Fields•

Rainbow-colored, patchwork fields of tulips are the ultimate symbol of the Netherlands in the spring. Ever since the first tulips were planted there during the 16th century, tulip fields have formed a colorful part of the Dutch landscape.

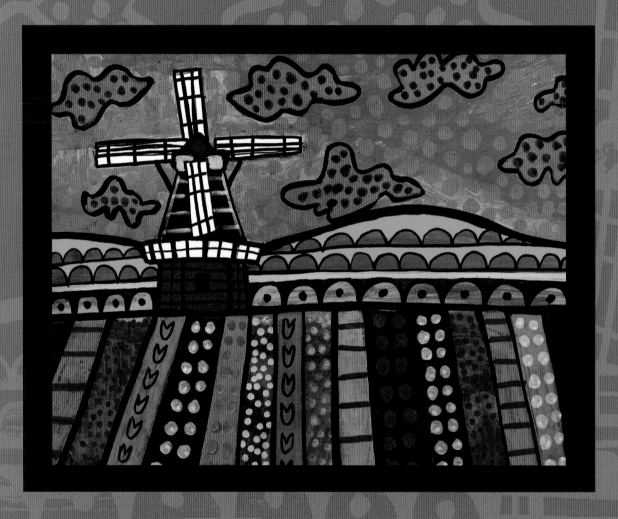

STEP 1

With a fine-tip black marker, copy the Dutch tulip fields template onto a sheet of paper.

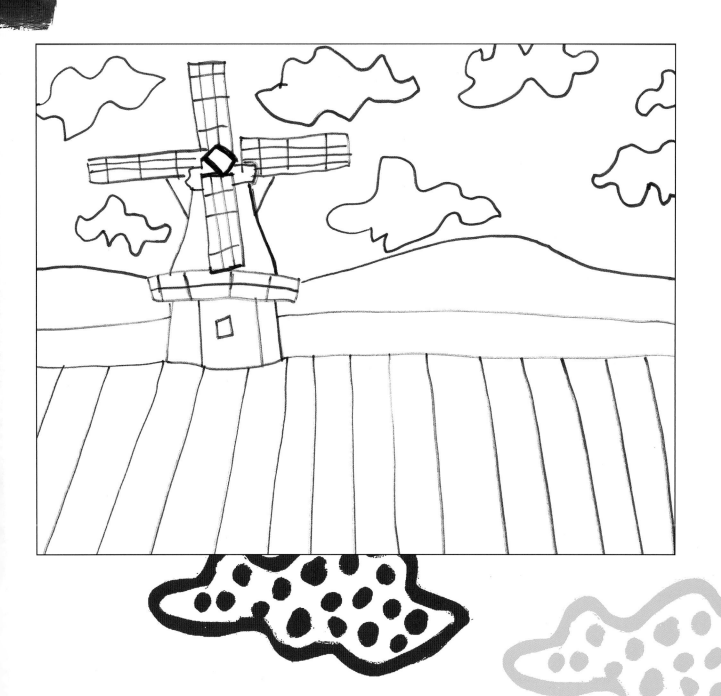

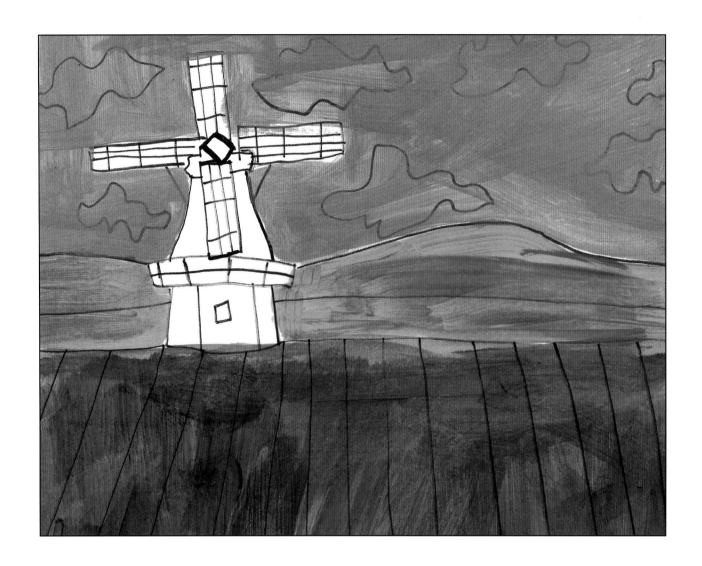

STEP 2

Paint the sky lilac with a medium, flat brush. Use the same type of brush to paint the middle part of the background bright green and the lower part of the background dark green.

STEP 3

Using a black medium-tip marker, outline the clouds, and then use a smaller marker to outline the windmill. Paint the windmill red and black using a small, flat brush. Using the same type of brush, paint the clouds pink.

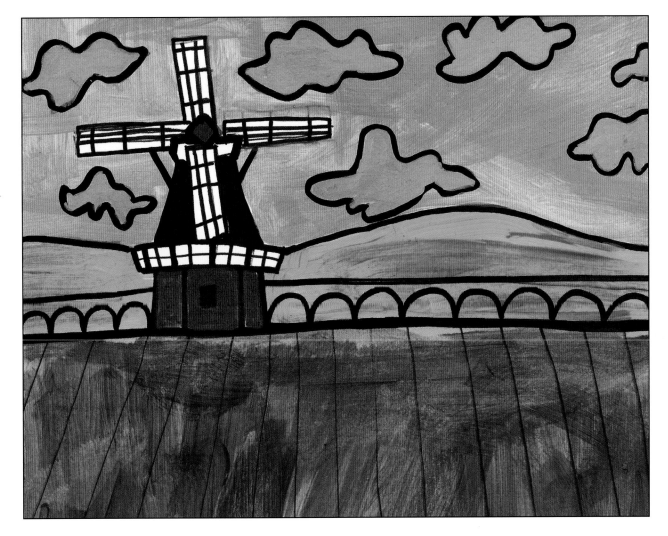

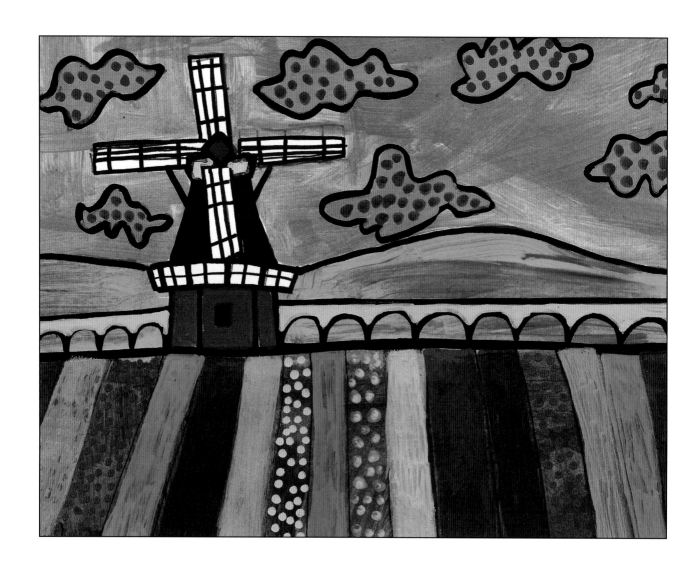

STEP 4

Now focus on adding color to the rows, which will become the flower fields, by painting some of them pink, purple, and bright green. Use orange, yellow, and white paint pens to add polka dots to the rows that you didn't paint. With a purple paint pen, add polka dots to the pink clouds.

STEP 5

Draw randomly sized polka dots in the sky with a pink paint pen. With a black medium-tip marker, draw thicker lines between the flower fields. Notice that each row has its own design; use the coordinating paint pen to create the desired design. Add details to the hills with green and black paint pens. Finally, with a fine-tip black marker, add line details to the windmill.

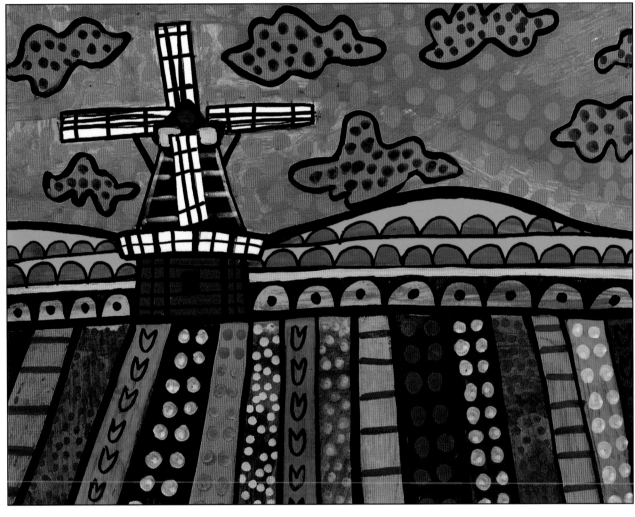

· Russian Nesting Dolls ·

A popular symbol of Russia, nesting dolls are decorated wooden figures that sit inside each other in decreasing size. These toys are called "matryoshka" in Russian, which means "little matron."

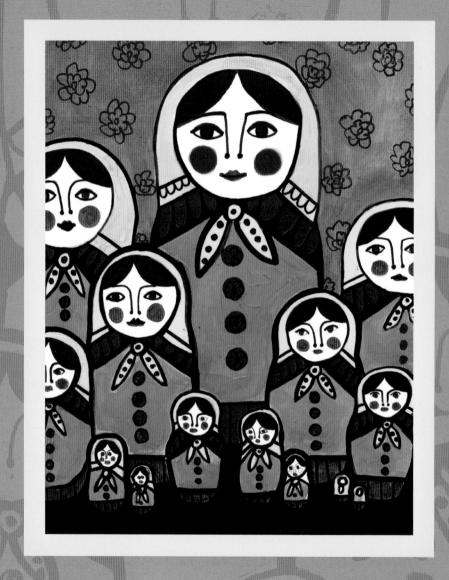

STEP 1

With a fine-tip black marker, copy the Russian dolls template onto a sheet of paper.

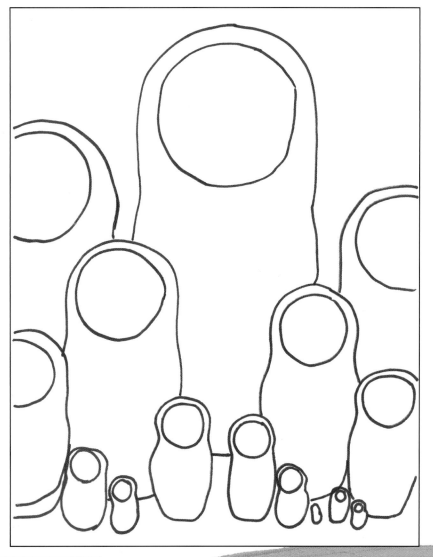

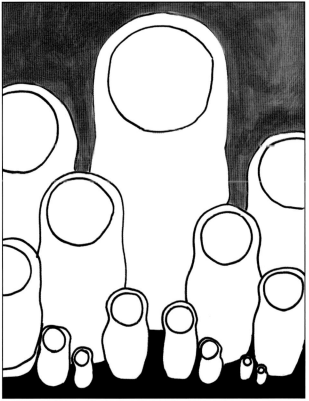

STEP 2

Paint the top portion of the background pink using a medium, flat brush. Use the same type of brush to paint the bottom part of the background black. You can use a fine-tip black marker for the smaller areas if you prefer.

STEP 3

Use a fine-tip black marker to outline the hair and clothing details on the dolls.

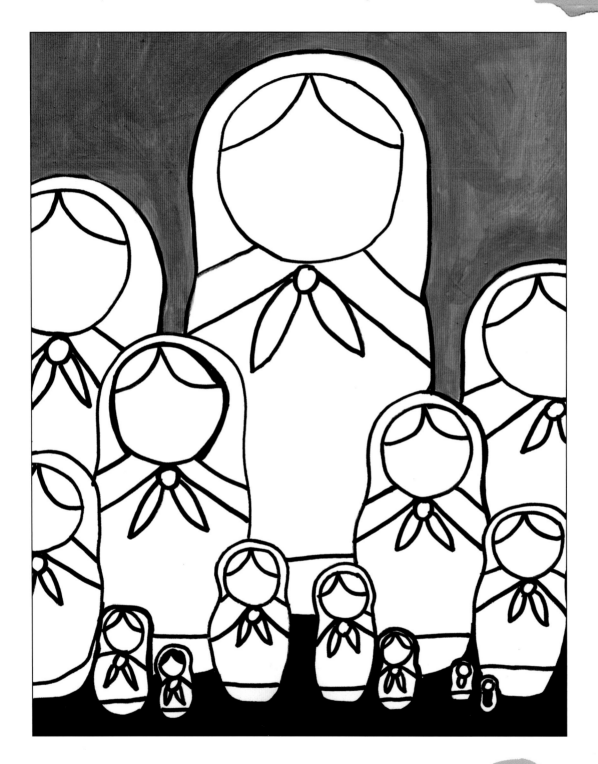

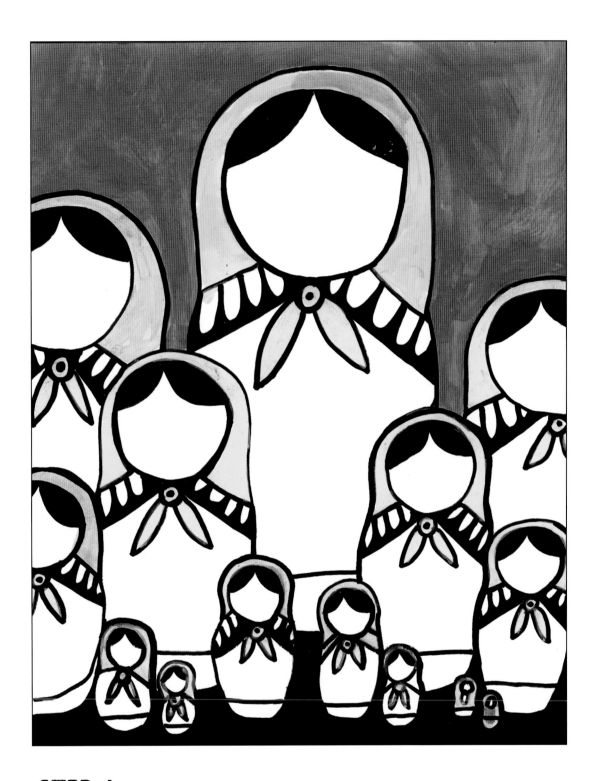

STEP 4

With a small, flat brush, paint the dolls' headdresses yellow. Use a
medium-tip black marker to fill in the trim area around the dolls' necks.

STEP 5

Use a red paint pen to fill in the trim around the dolls' necks. With a fine-tip red marker, draw randomly sized flowers in the background. Now use a small, flat brush and magenta paint to color in the bottoms of each doll. With a fine-tip black marker, add polka dots to each yellow tie.

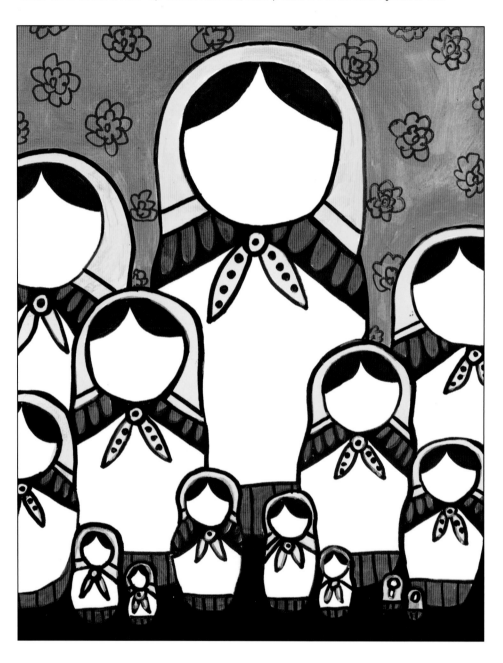

STEP 6

Draw faces on each doll with a fine-tip black marker. Create circles for the cheeks with a hot-pink paint pen. With a small, flat brush, paint each doll's dress aqua, and then let the painting dry completely. When it's dry, use a red paint pen to create flower buttons on each doll's chest, and then add details on the buttons with a fine-tip black marker.

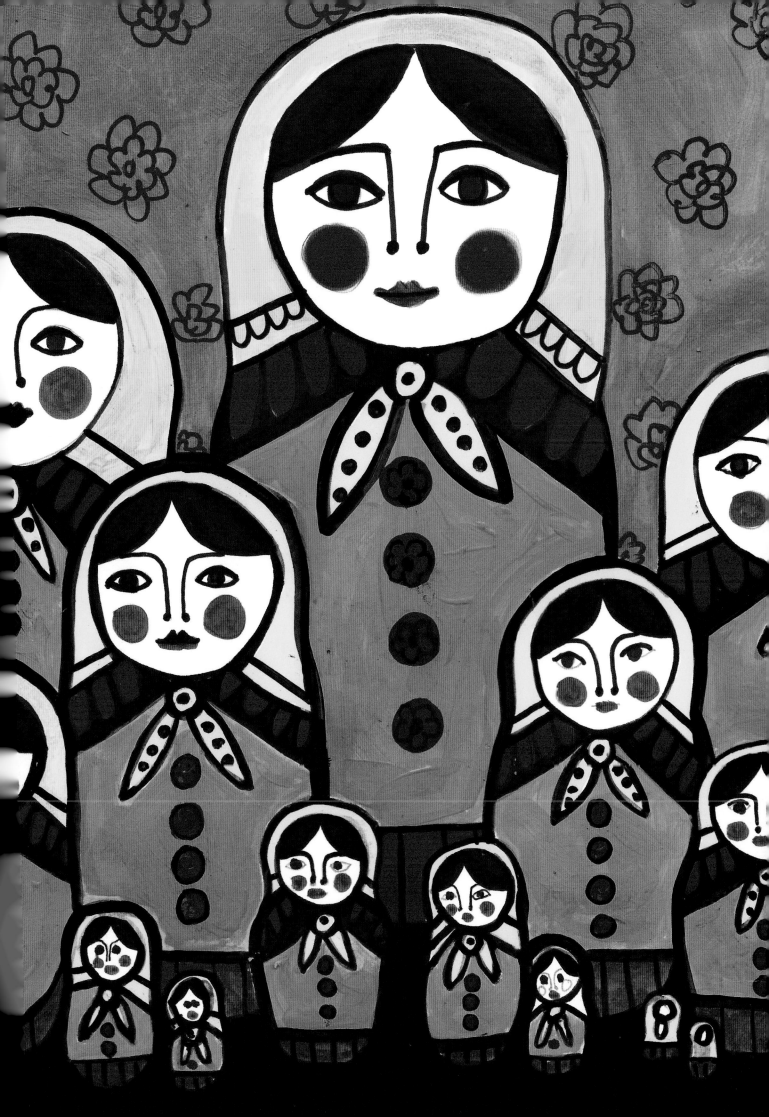

• Dala Horse •

Dala horses (also known as "Delecarlian horses") began as wood-carved, painted toys for Swedish children. The folk-art horses gained international popularity after they were introduced at the World's Fair in New York in the 1930s, and now they serve as a symbol of Sweden.

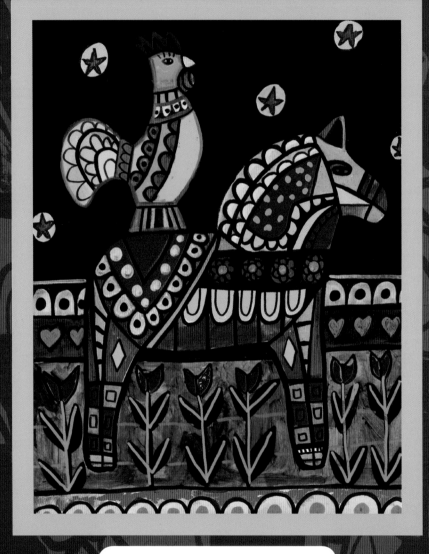

STEP 1

With a fine-tip black marker, copy the Dala horse template onto a sheet of paper.

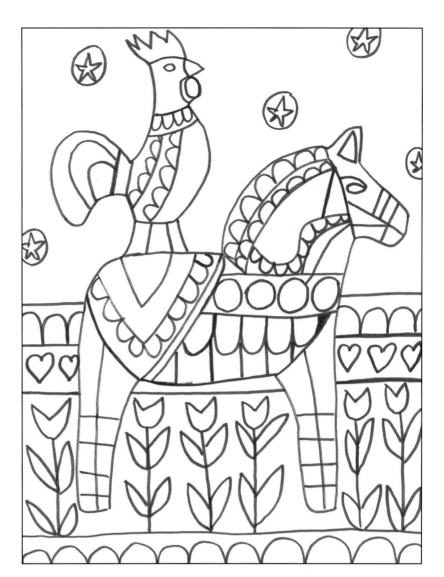

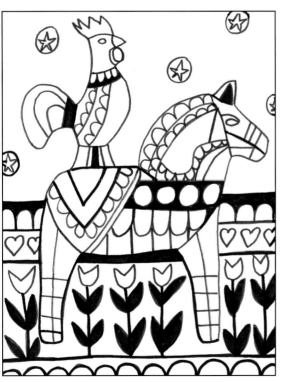

STEP 2

Use a small, flat brush to fill in the larger areas of black with black paint. Alternatively, use a broad-tip black permanent marker.

STEP 3

With a small, flat brush, paint the background behind the tulips with a thin layer of green. Let the paint dry, and then apply a second coat. You're trying to achieve a dark-green color, so you might need three coats of paint depending on the type you use. With a small, flat brush, paint the designs on the horse and the rooster's feathers red. Paint the horse's mane and the bottom trim of the painting yellow.

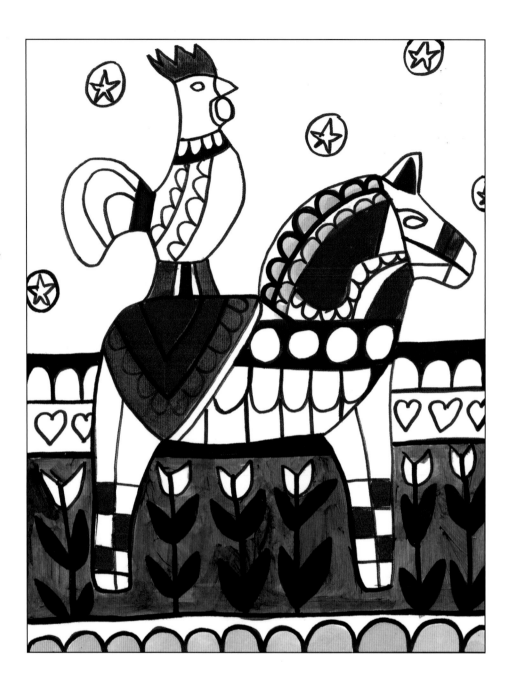

 Acrylic paint dries much faster than oil-based paint.

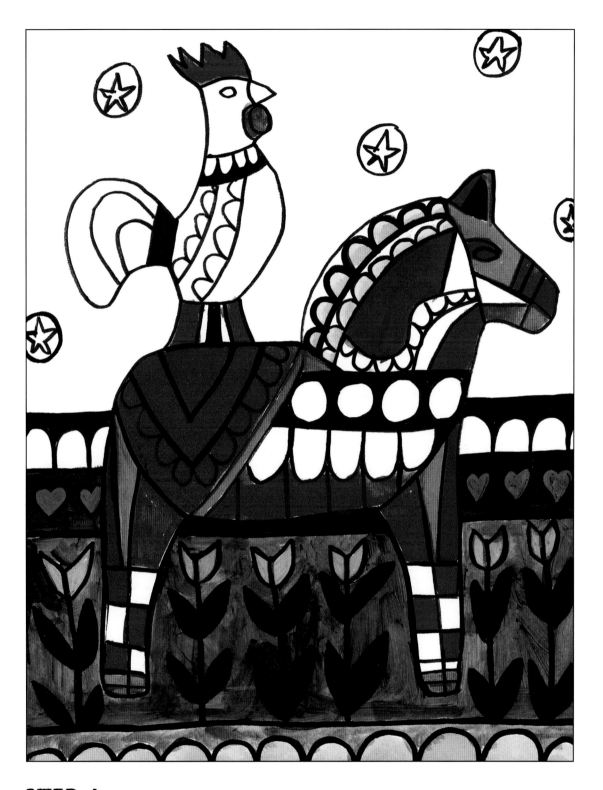

STEP 4

Paint in the different sections of the horse and the row of hearts using orange, hot-pink, light-pink, baby-blue, and bright-blue paint. Let the paint dry, and then use a small, flat brush and black paint, or a black marker, to clean up the lines.

STEP 5

Paint the sky black, and then clean up the lines with a black permanent marker. Paint the rooster light green, orange, and teal, and use the same teal paint on the horse. Paint the four circles on the horse's body bright blue and the six squares on the horse's legs green. Use a black fine-tip marker to draw black boxes in the red and green boxes on the horse's legs. Use a black marker to draw dots in the trim above the row of hearts. With a green paint pen, make dots on the yellow trim at the bottom of the painting.

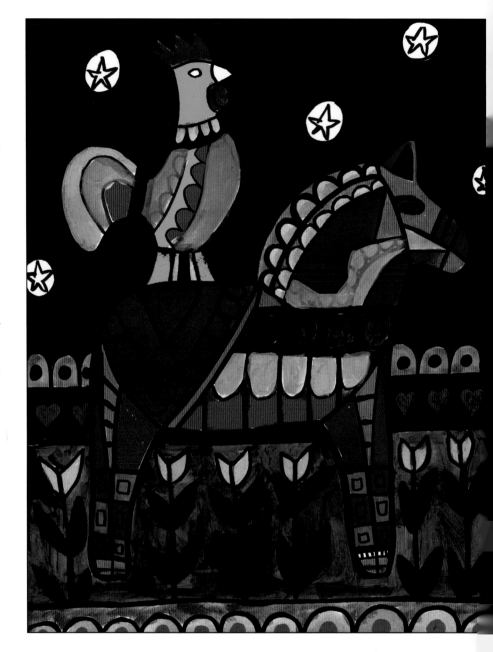

STEP 6

Fill in the circular backgrounds of the stars with mint-green paint, and then paint the stars with an orange paint pen. Add details to the horse and rooster with a yellow paint pen, and then use a light-green paint pen to add details to the tulip stems, dots on the horse's head, diamonds on the legs, and semi-ovals on the body. Use fine- and medium-tip black markers to add any remaining black details and clean up the lines.

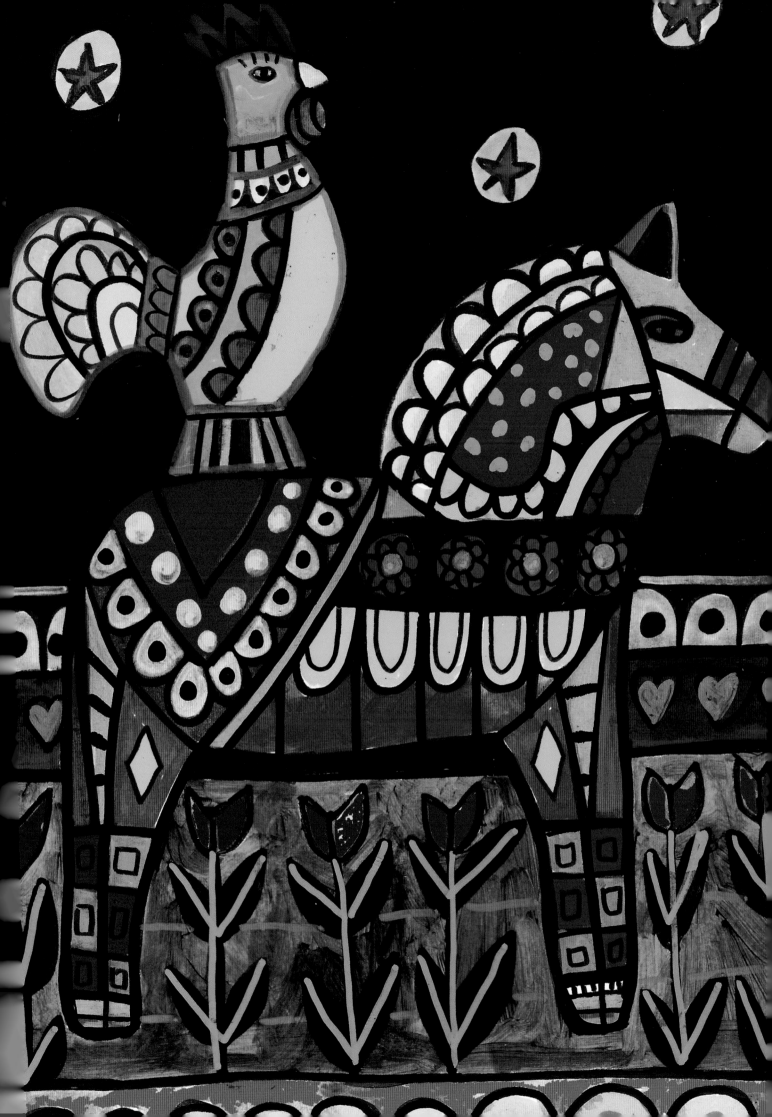

English Cottage

A small, cozy dwelling, an English cottage is an old-fashioned house in which all of the rooms fit under one tiny roof.
This cottage is unique because it's shaped like a teapot!

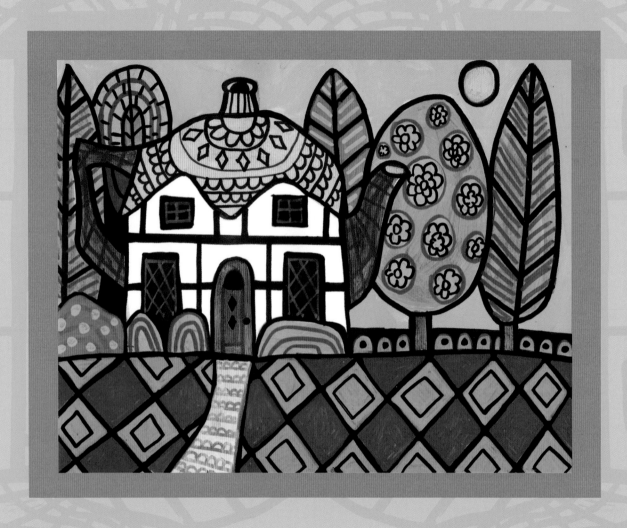

STEP 1

With a fine-tip black marker, copy the English cottage template onto a sheet of paper.

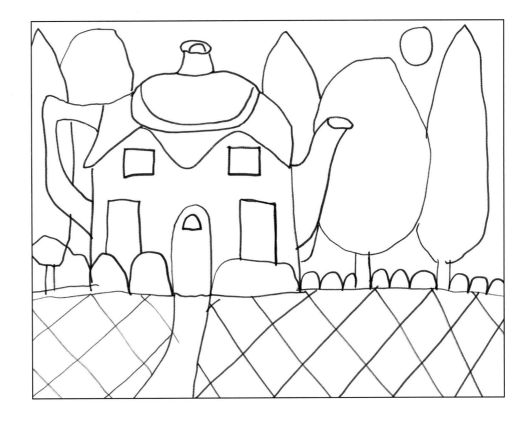

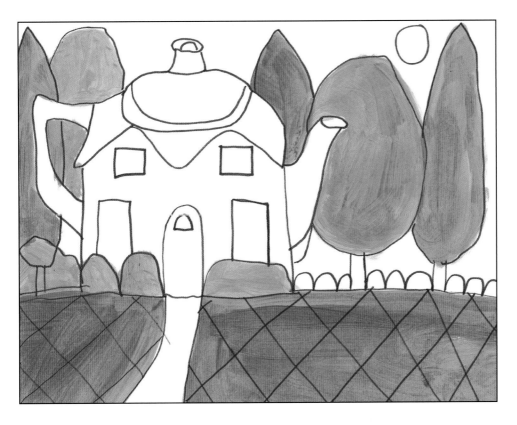

STEP 2

Using a medium, flat brush, paint the grass and three of the trees dark green. Use the same brush and bright-green paint to fill in the remaining trees and bushes.

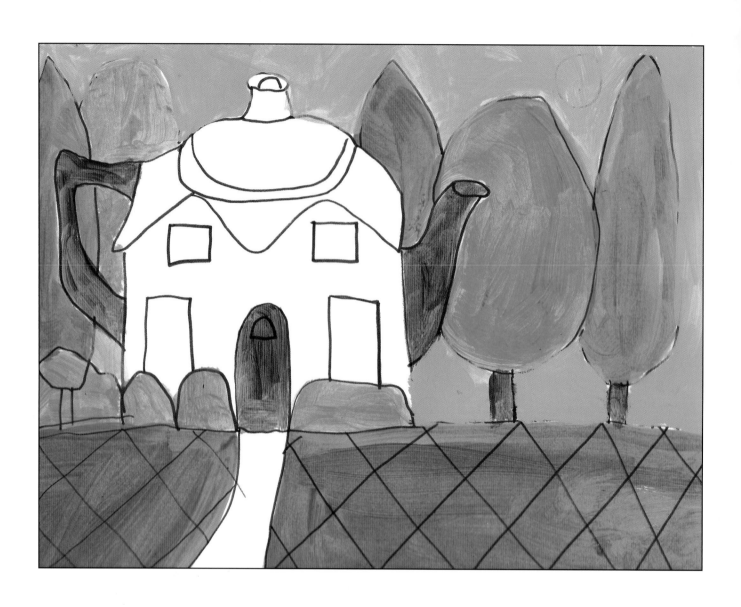

STEP 3

Now use a small, flat brush to paint the tree trunks, teapot handle, and spout brown. With a medium, flat brush, paint the sky aqua.

STEP 4

Paint the roof and walking path yellow using a small, flat brush. Use a medium-tip black marker to fill in the windows, draw lines on the house, and outline the trees and grass.

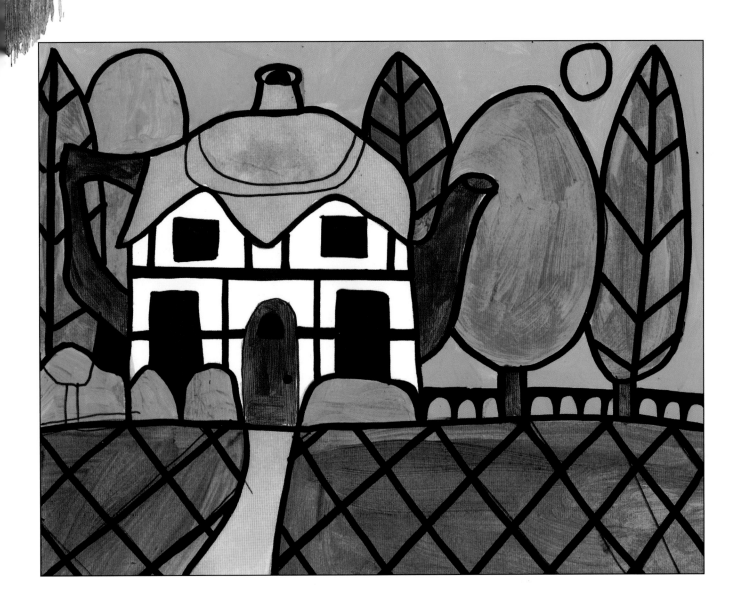

STEP 5

With dark-green and light-green paint pens, fill in the grass area, alternating colors as you go. Use the same pens to add details to the trees: Draw circles, curved lines, and straight lines to make patterns. Then draw details on the handle and spout, and add details to the door. With an aqua paint pen, draw details on each window. With a small, flat brush, paint the circle in the sky light blue.

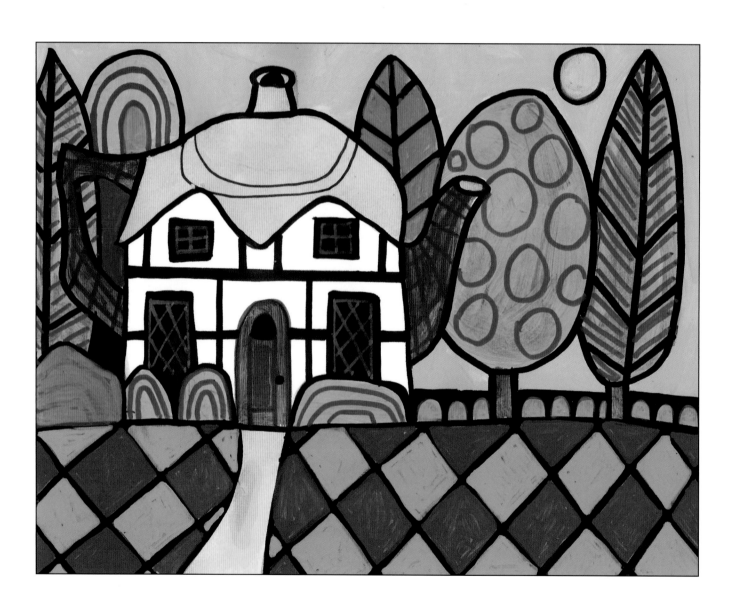

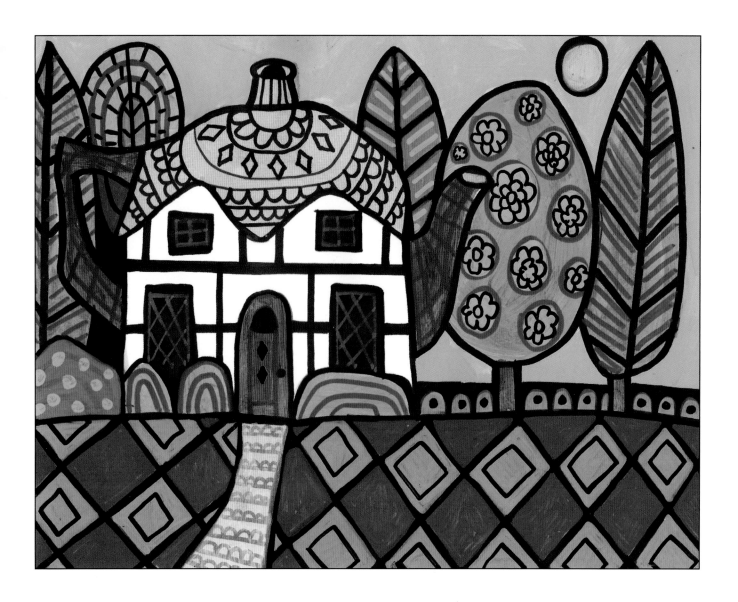

STEP 6

Now it's time to add the intricate flourishes to the house. With a fine-tip black marker, draw details on the roof and the walking path. Use the same marker to draw square details on the grass and flowers in the trees, and outline the other trees. Use light green to add details to the tree in the center.

• Girl Holding a Cat •

Traditional American folk art portraits of children were commonly painted
with a prop that was important to the child, such as an animal.

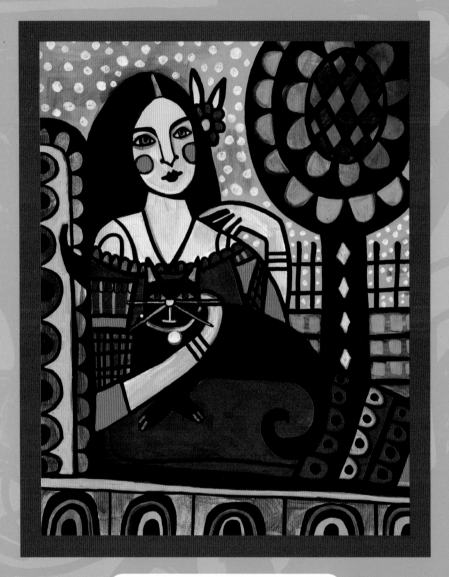

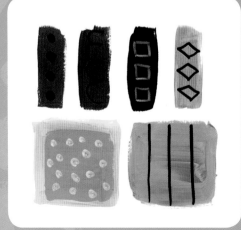

STEP 1

With a fine-tip black marker, copy the template onto a sheet of paper. Now fill in the hair, the cat, and the stripe of the seat under the girl with black paint and a small, flat brush. Alternatively, you can fill in these areas with a broad-tip black permanent marker.

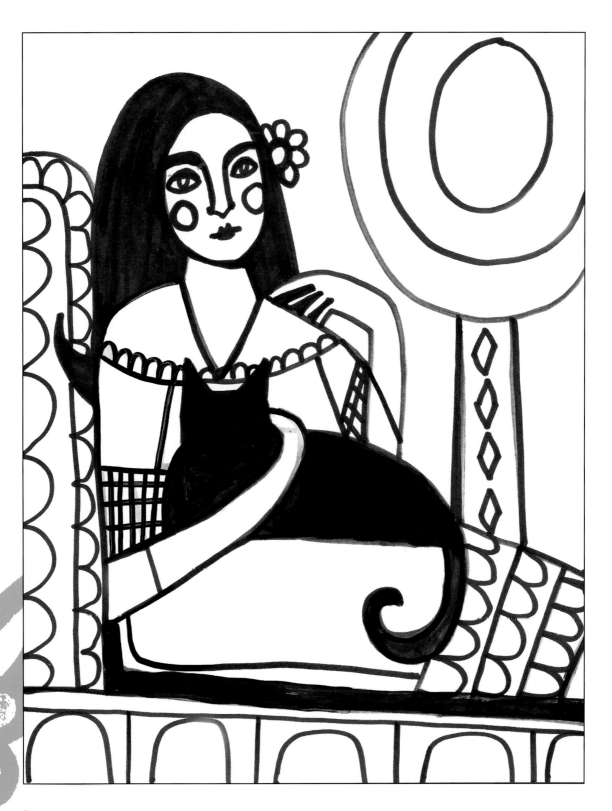

STEP 2

Paint the background yellow with a medium, flat brush. With the same type of brush, paint the tree and bottom half of the background bright green. Let the painting dry completely.

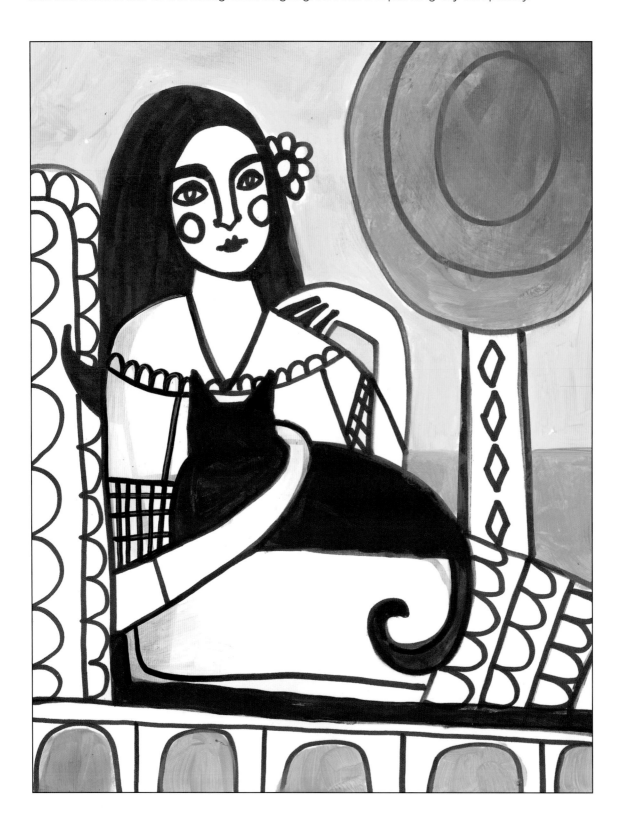

STEP 3

Apply a thin coat of baby-blue paint over the yellow background with a medium, flat brush. You will probably see some of the yellow through the layer of blue paint, and that's fine. In fact, that is the desired effect. With a medium, flat brush, paint the chair brown. Then use a black or green marker to draw details on the tree, preparing it for more painted detail later. Now paint the girl's dress bright red with a small, flat brush. To get a rich color, you might need to paint two or three layers of red. Let the paint dry, and then add the cat's crossed arms on the girl's lap with a fine-tip black marker.

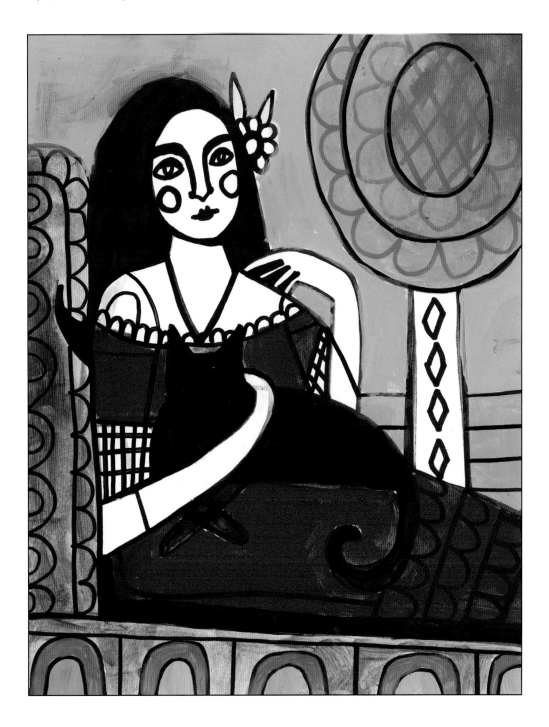

STEP 4

Now focus on the girl's skin by painting it pale pink with a small, flat brush. Don't worry about going over the lines; they will still show through and you can use them as guidelines when you redraw them later. Using the same type of brush, paint the details of the girl's dress and the flower in her hair with bright-pink paint. Paint the tree trunk brown using a medium, flat brush.

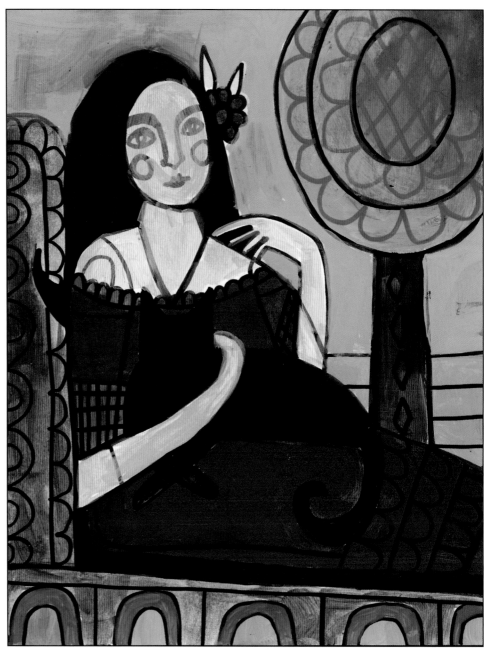

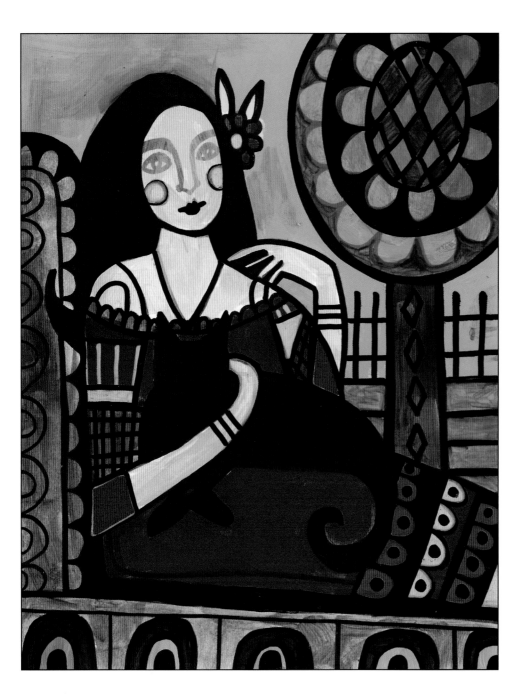

STEP 5

With fine- and medium-tip black markers, draw the details of the chair by filling in the trim. With the same markers, fill in the details on the tree by going over the lines and filling in the black area around the trim. With a fine-tip black marker, add lips and cheeks to the girl's face. Using a medium-tip black marker, work on the details of the dress, filling in around the trim. Draw the fence in the background with a medium-tip black marker.

STEP 6

With a white medium-tip oil paint pen, add randomly sized polka dots to the background. Then let the painting dry until the paint is no longer tacky to the touch. Once it's dry, use the same white oil pen on the cat's face and collar as well as the diamonds on the tree trunk. With a small, flat brush, paint the girl's cheeks bright pink, and then use the same paint and brush to fill in the details of her dress.

Now draw in the girl's eyes, nose, and eyebrows using a fine-tip black marker. Brighten the chair with a bit of yellow by painting the seat and back using a small, flat brush. Finish the tree by adding a layer of dark brown to the trunk. Clean up all of the lines in the painting by going over them with a black pen.

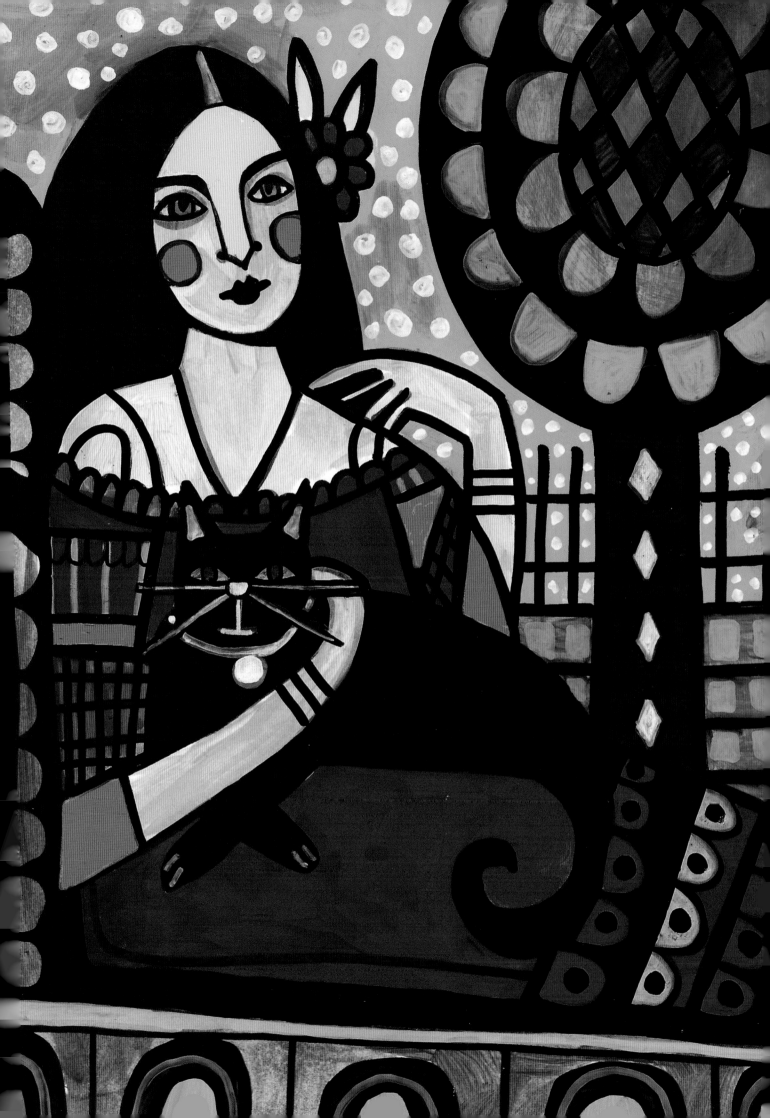

•Newport, Rhode Island•

The seaside city of Newport, Rhode Island, was founded in 1639. This New England city is
famous for its historic colonial homes, two of which were owned by United States presidents
Dwight D. Eisenhower and John F. Kennedy.

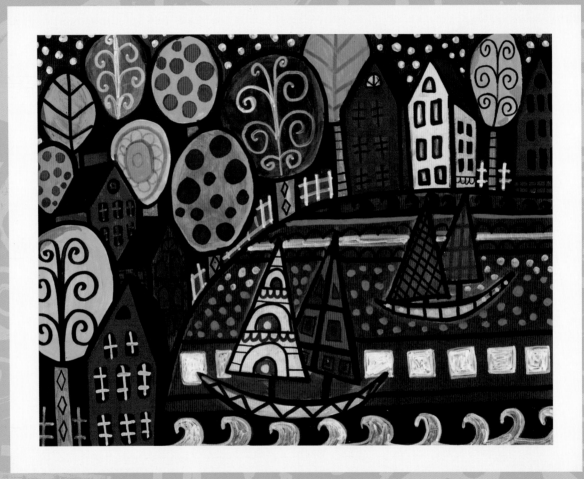

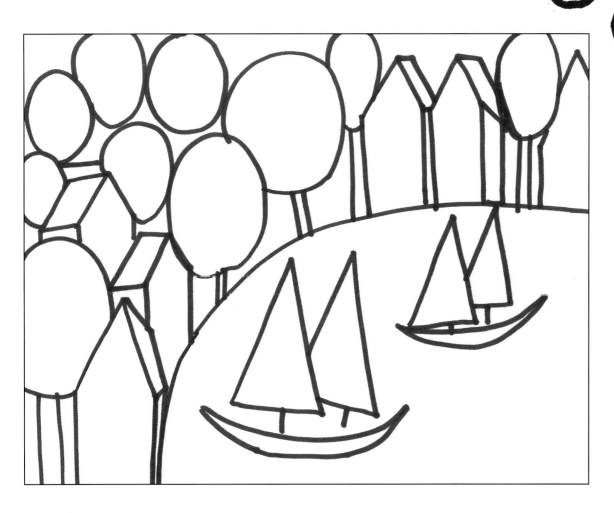

STEP 1

With a fine-tip black marker, copy the Newport template onto a sheet of paper.

STEP 2

Using a small, flat brush, paint the water blue. Use the same brush and a darker shade of blue to fill in the sky. Let the paint dry completely.

STEP 3

Add another coat of blue paint to the sky and water areas, and let it dry. Once it's dry, use small- and medium-tip black markers to fill in the roofs and areas around the trees. Using a small, flat brush, paint three of the houses red, applying a couple of coats of paint to produce a rich and vibrant color. Paint another one of the houses magenta.

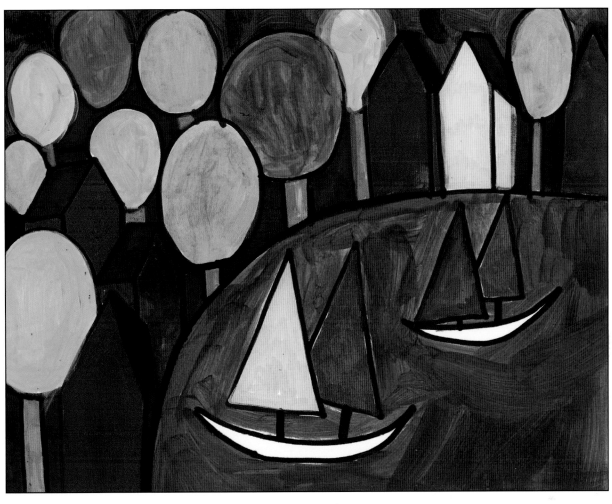

STEP 4

With a small, flat brush, paint the trees alternating shades of dark green and light green. Using the same type of brush, paint the tree trunks brown. Paint the two remaining houses purple and yellow. Use a small, flat brush to paint the boats' sails orange, yellow, and purple.

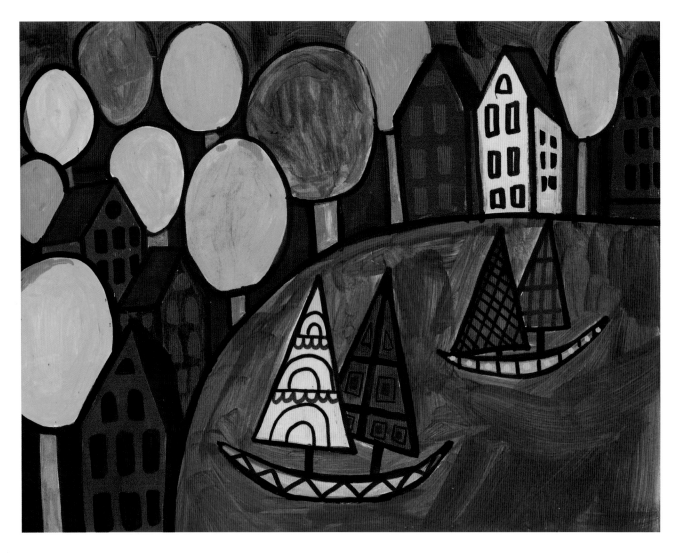

STEP 5

Paint the bottoms of the boats baby blue, and then add details to the sailboats using red, yellow, and black paint pens. Then use a fine-tip black marker to add windows on the houses.

Take care of your brushes! Wash them immediately after you're done with them, and dry them with the bristles pointing up.

STEP 6

Add polka dots to the sky with a white paint pen, and then add a white picket fence between the trees and waves to the water. With the same white paint pen, add details to two of the trees. With red and orange paint pens, add polka dots of various sizes to three of the trees. Use a fine-tip black marker to add details to the remaining trees. Finish the painting by creating details on the windows with yellow and black paint pens.

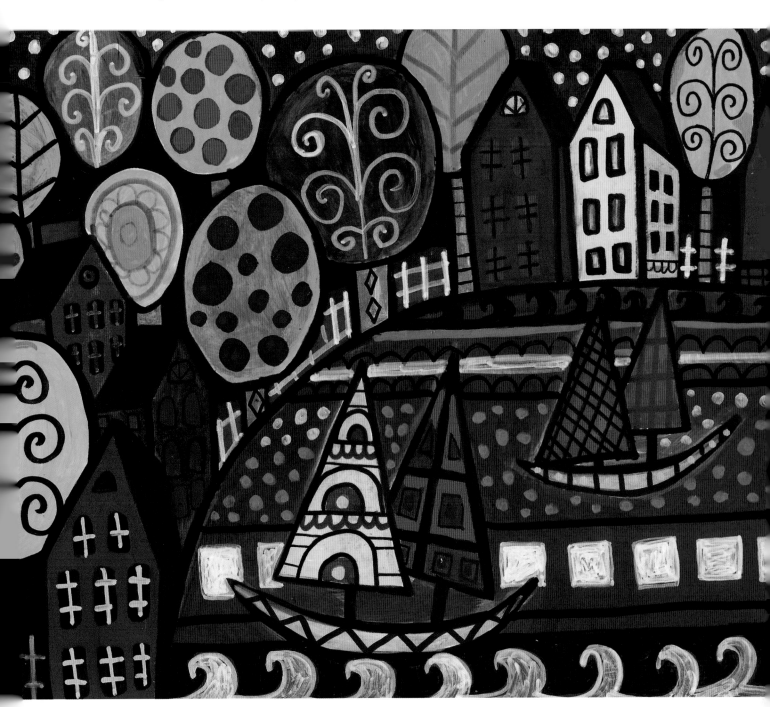

• Farm Landscape •

This landscape is based on Green Acre Farms, a U-pick farm that was located an hour away from where I grew up in upstate New York. The 40-year-old farm had the most beautiful prune blossom trees and rows of apples, blueberries, currants, pumpkins, and raspberries.

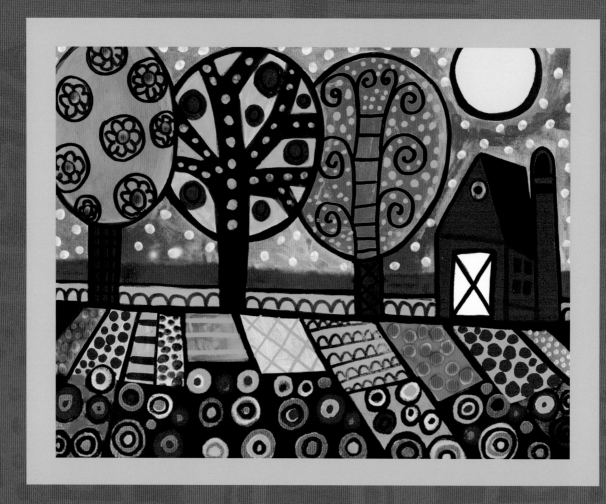

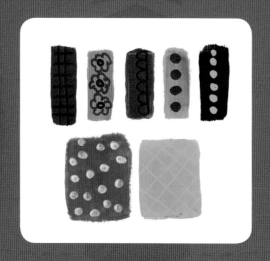

STEP 1

With a fine-tip black marker, copy the farm template onto a sheet of paper.

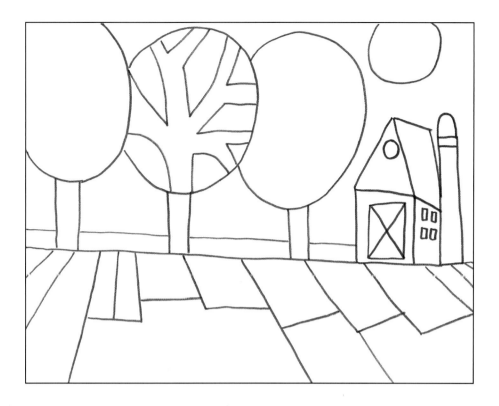

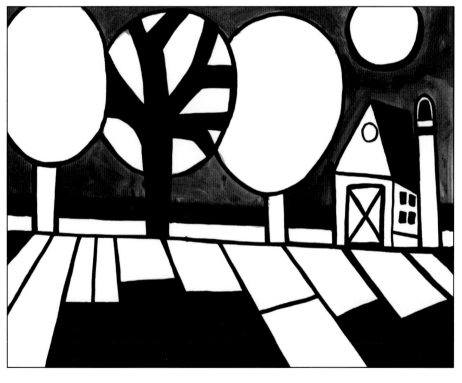

STEP 2

Use a small, flat brush and black paint to fill in the branches of the middle tree, part of the ground, and the roof and silo of the barn. Alternatively, you can use a broad-tip black permanent marker. Fill in the sky with blue paint, and then use a medium, flat brush to paint a blue stripe across the horizon line. You might need to apply three or four coats to darken the area.

STEP 3

Paint all of the grass and trees with one layer of green paint, and let it dry. Apply a second layer of paint to the first and third trees and to a few of the field blocks. Let the paint dry. If you wish, go over the darker green areas with yet another coat of green paint, and then let it dry. With a black permanent marker, add detail to the field near the horizon line.

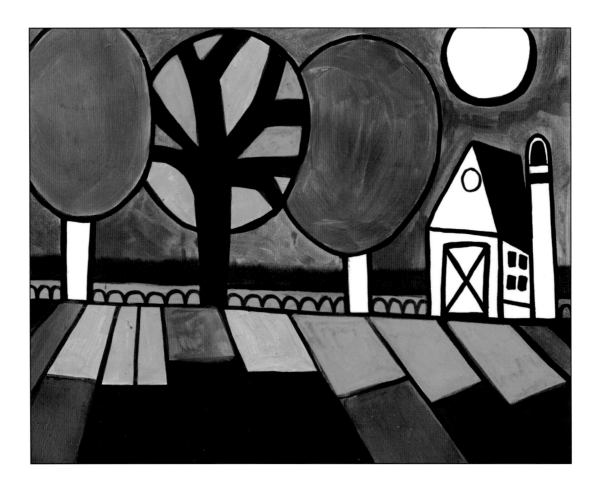

STEP 4

Using a small, flat brush, paint the first and third tree trunks bright red. Paint the barn and silo too—all except for the barn door and the circular window at the top. With a red paint pen, draw red circles on the middle tree between the branches, and then draw small circles on two of the field blocks. Let the paint dry, and then add details to the trees with a black permanent marker.

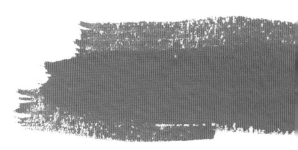

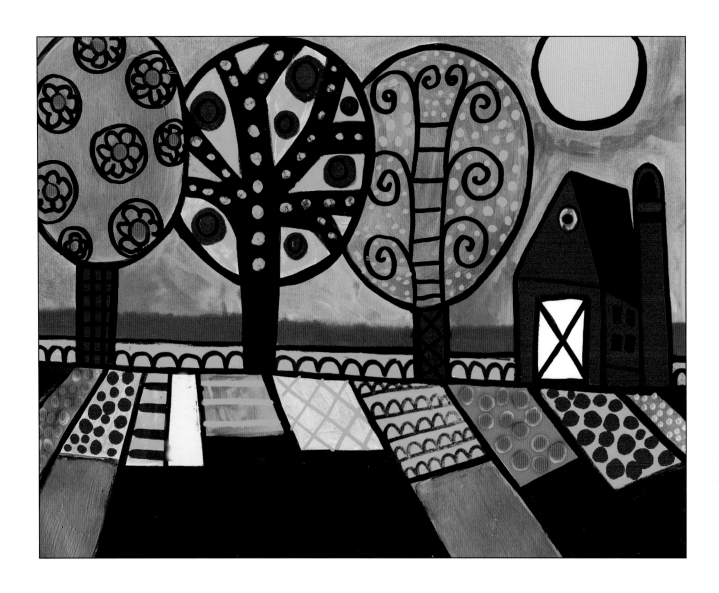

STEP 5

Draw flowers in the first tree with a fine-point black marker, and then paint in the flowers' centers using a hot-pink paint pen. Use the paint pen to add color to the little circular window on the barn. Add details to the green field with hot-pink, light-green, and red paint pens. Let it dry. With a light-green paint pen, add dots to the branches of the second tree as well as to the green part of the third tree. With a small, flat brush, paint the moon above the barn and one of the field blocks baby blue. Let the paint dry for at least one hour or until the paint is no longer tacky to the touch.

STEP 6

Add flowers to the field by drawing circles with red, yellow, orange, white, blue, and green paint pens. Use a white paint pen to add dots to the sky. Let the painting dry, and then clean up the lines with a black permanent marker.

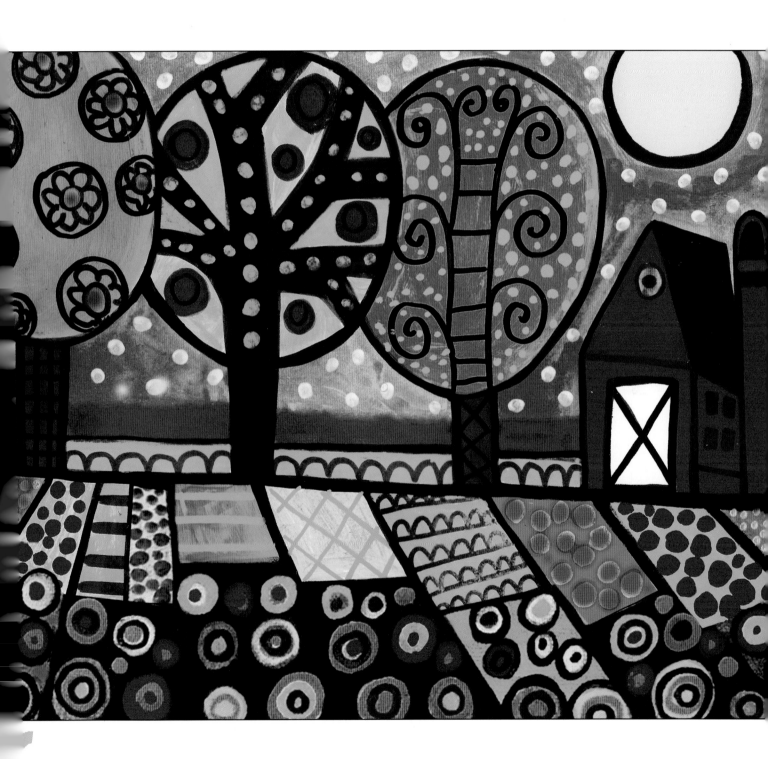

Carlsbad, California

Along the Pacific coastline sits Carlsbad, a city in Southern California. Among other things, Carlsbad is known for its agricultural landscapes, where numerous fields of avocado, citrus, and olive trees grow.

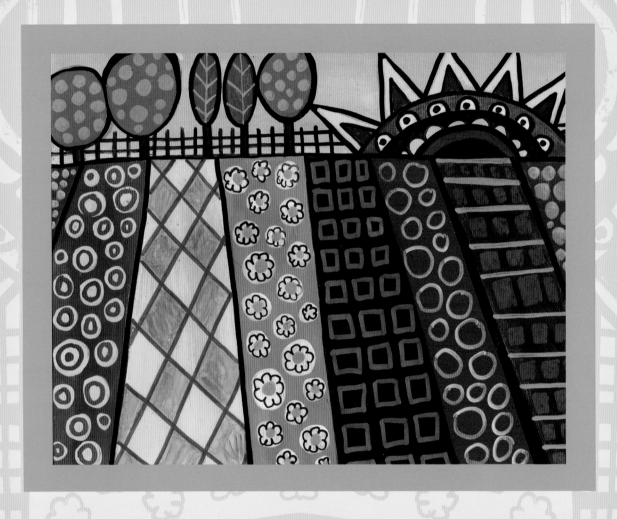

STEP 1

With a fine-tip black marker, copy the Carlsbad template onto a sheet of paper.

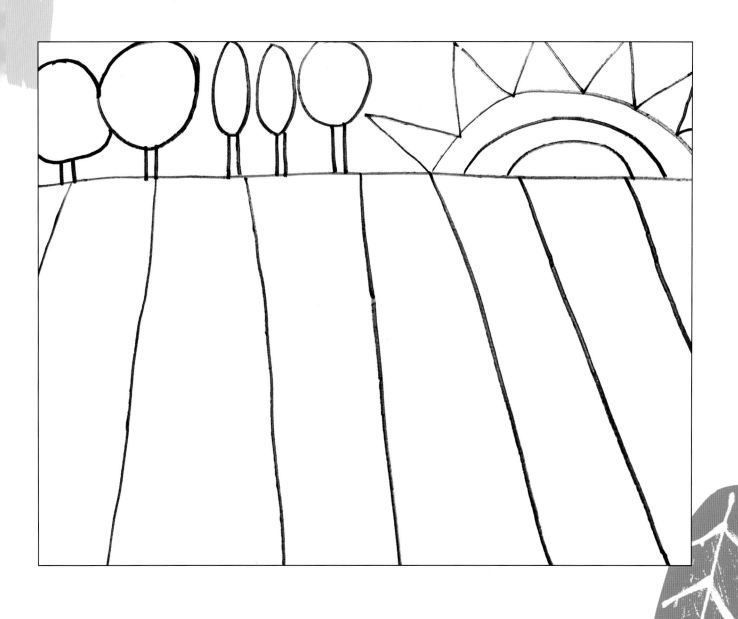

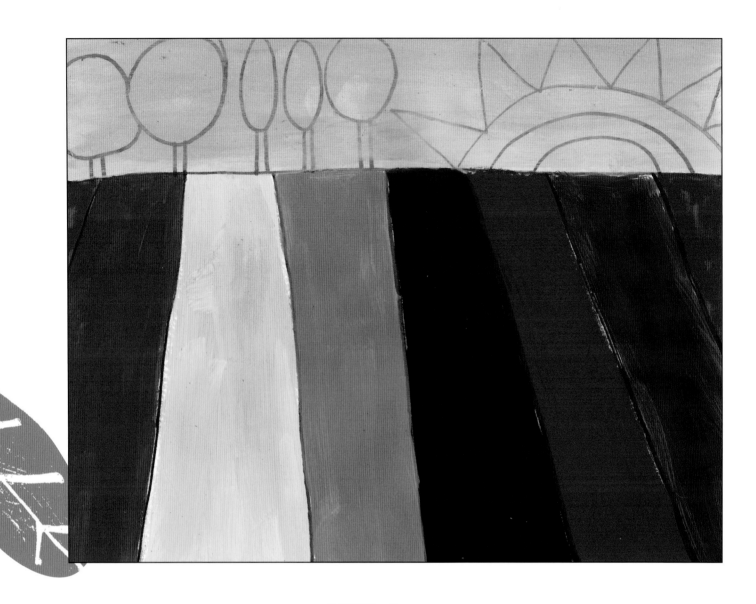

STEP 2

Paint the sky and one of the rows yellow with a medium, flat brush. Don't worry if you're painting over the black lines in the background; you're going to redraw them in a later step. Now use the same type of brush to paint the remaining rows red, pink, magenta, and black.

STEP 3

Using a small, flat brush, paint the trees two layers of green, letting the first layer dry completely before adding the second. When the painting is dry, outline the trees with a medium-tip black marker. Use the same marker to outline the rows and the sun. With an aqua paint pen, add line details to the yellow row and square details to the black row.

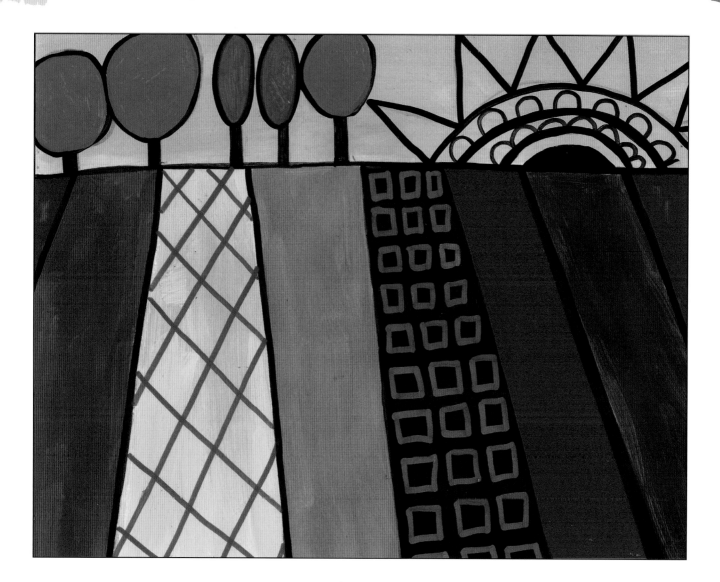

STEP 4

Draw circles and branch details on the trees with a light-green paint pen, and then use the same pen to draw lines on the purple row. With a yellow paint pen, draw polka dots on one of the red rows; with a white paint pen, draw polka dots on the pink row. With pink and red paint pens, fill in the sun details.

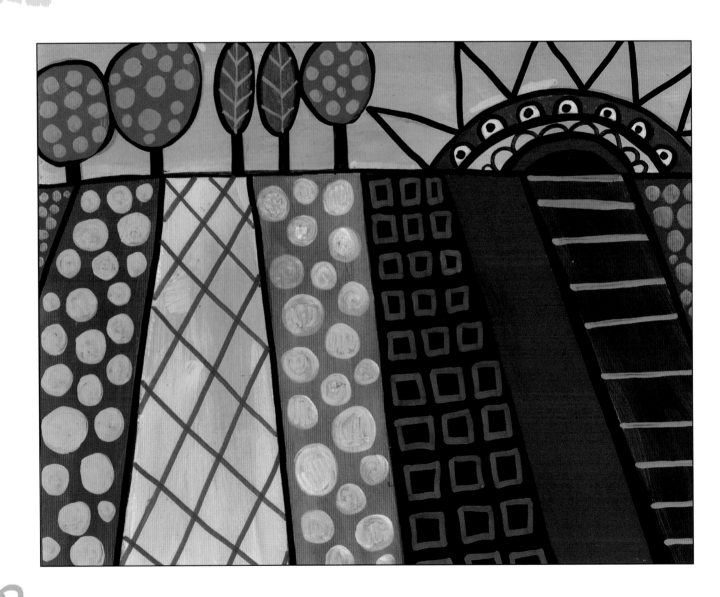

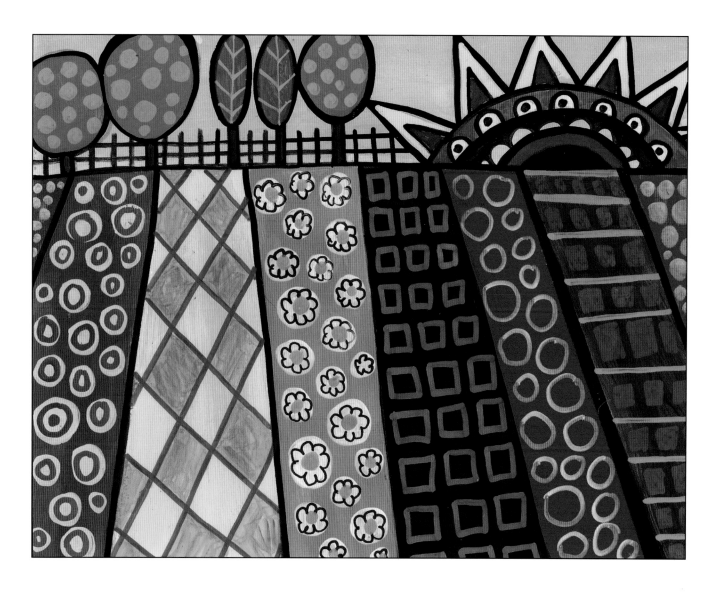

STEP 5

With a small, flat brush, paint bright-green squares in the yellow row. Then with a red paint pen, add details to the yellow polka dots. Use a fine-tip blue marker to draw flowers on the white polka dots. Draw circles on the red row with a white paint pen, and add squares to the purple row with a lilac paint pen. Finally, use a fine-tip black marker to create a fence in front of the trees.

Inspiration Gallery

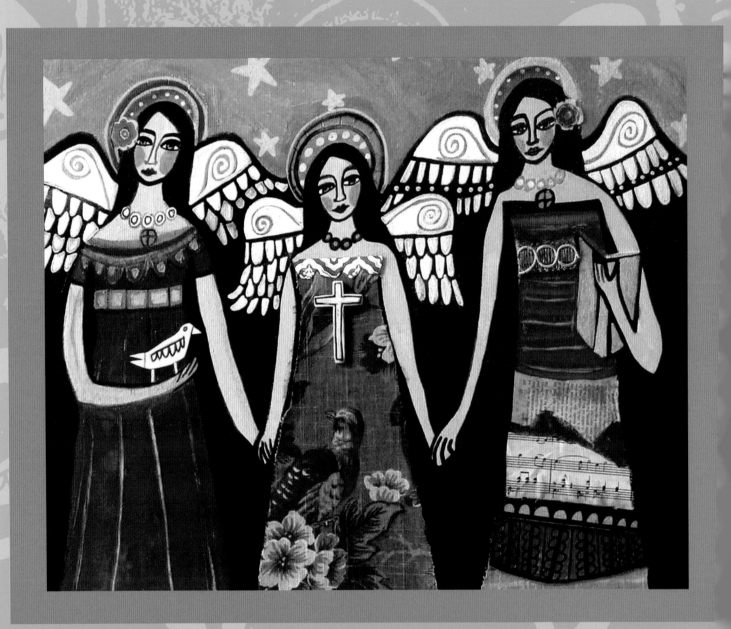

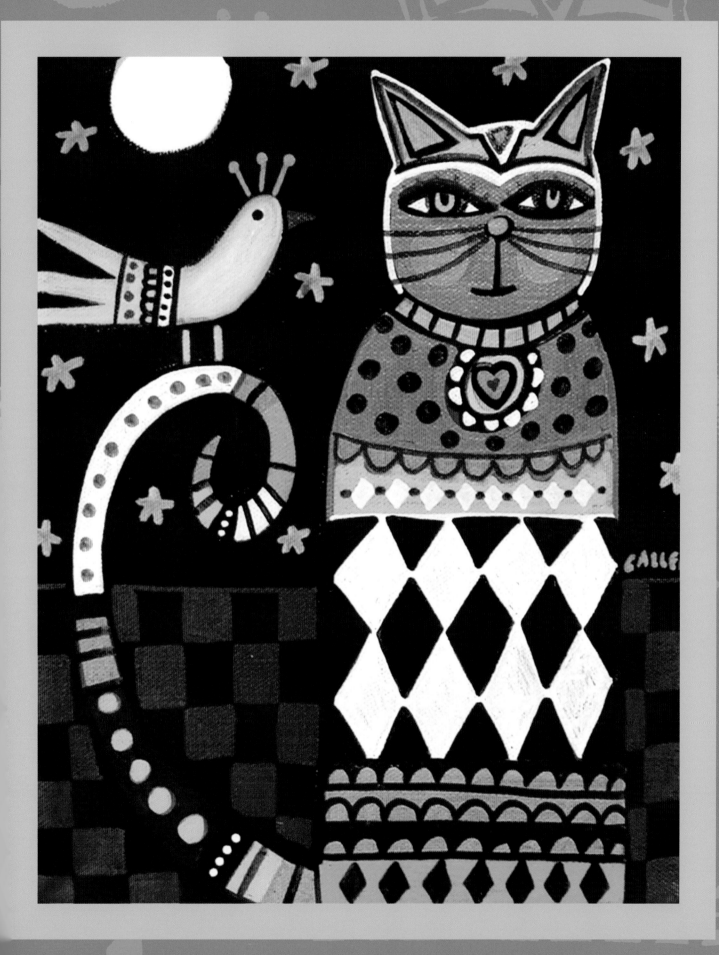

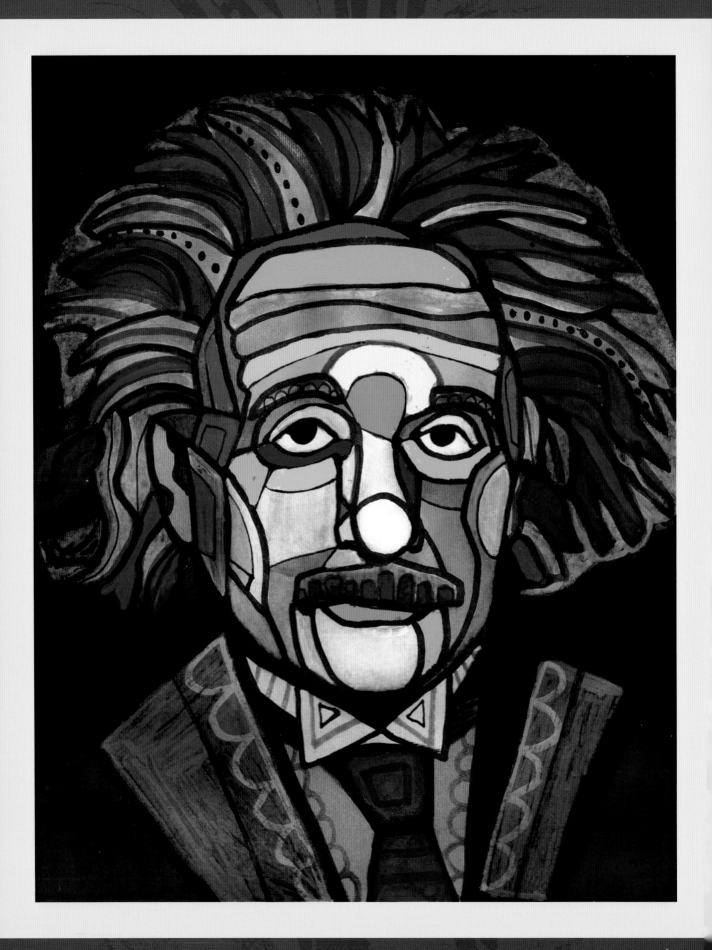

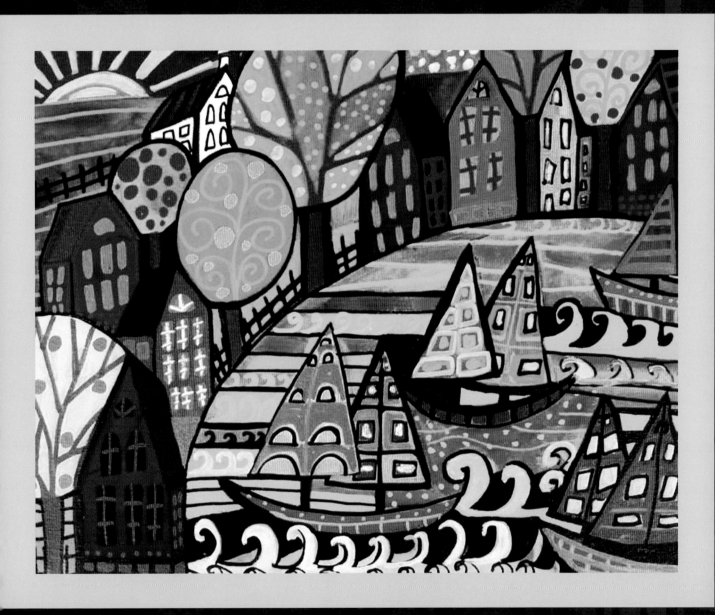

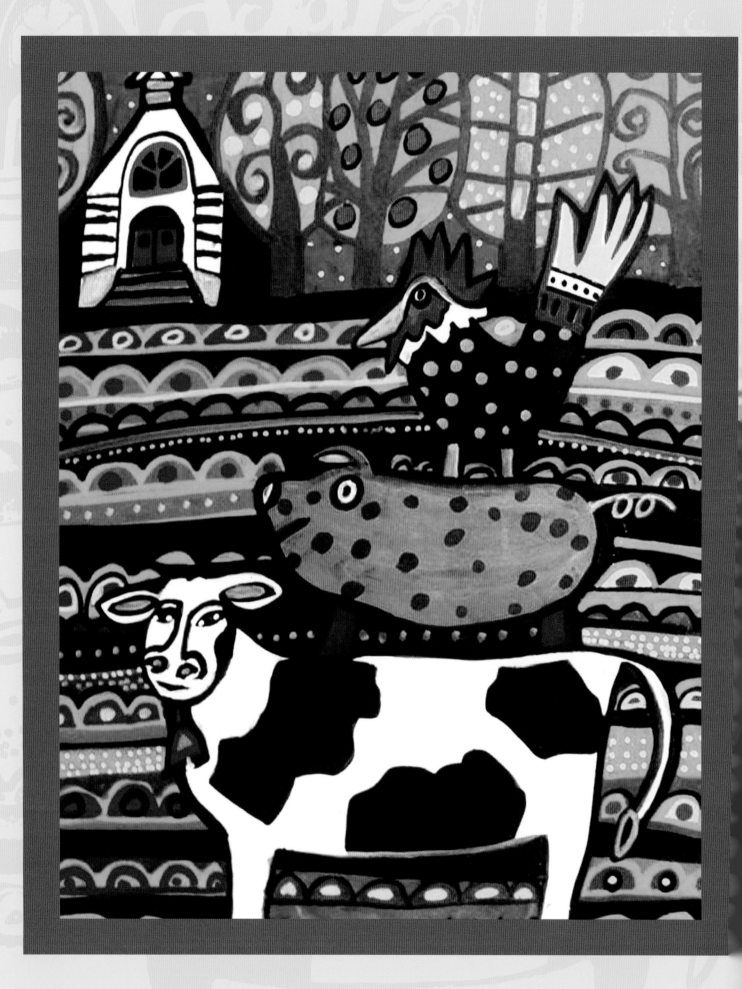

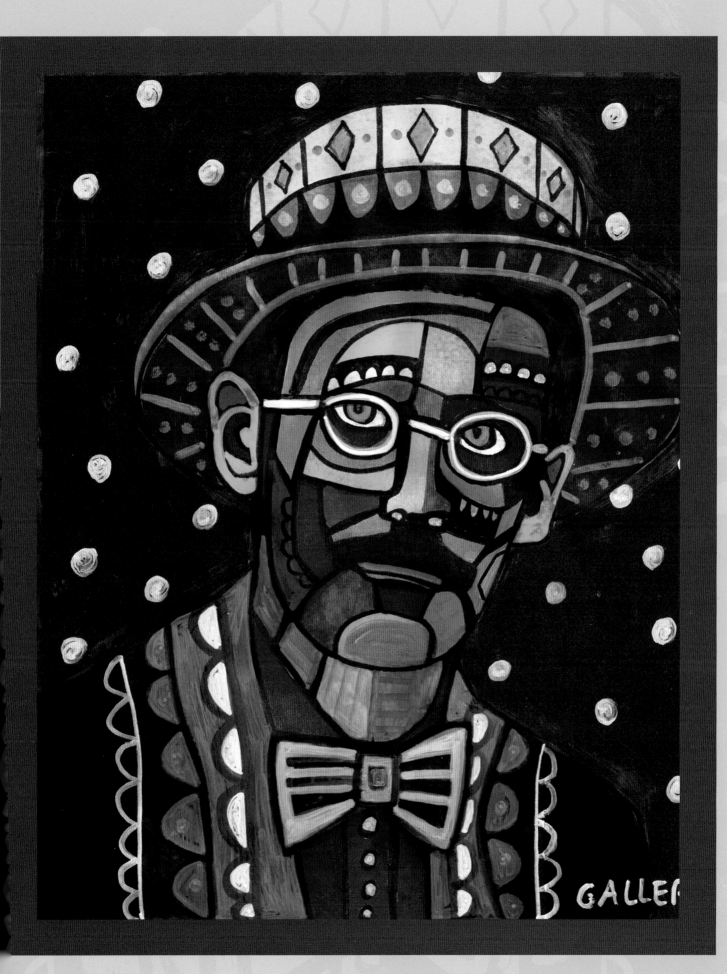

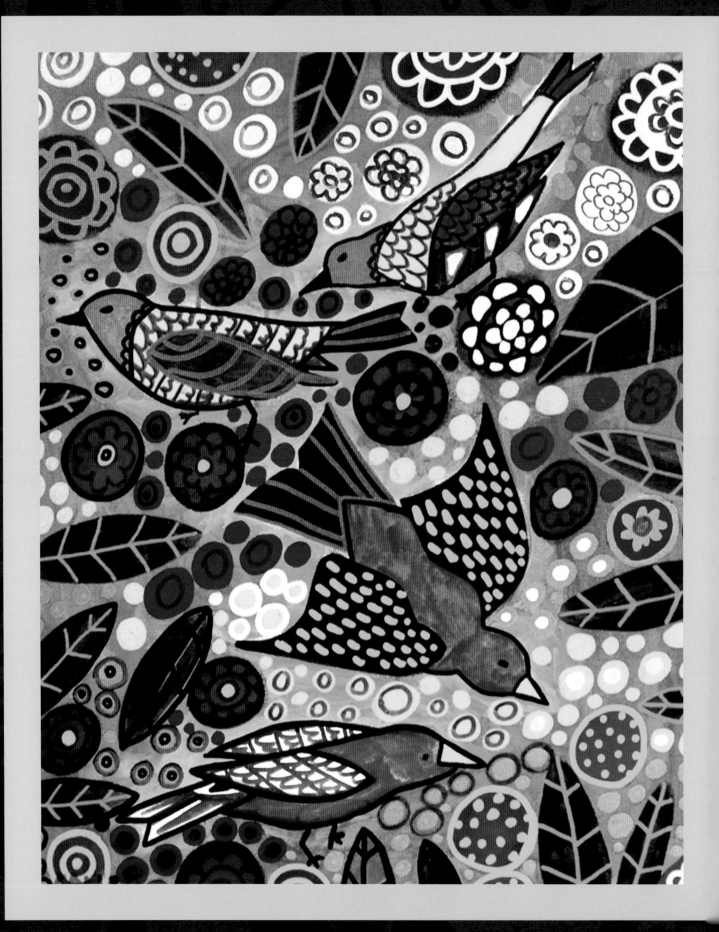

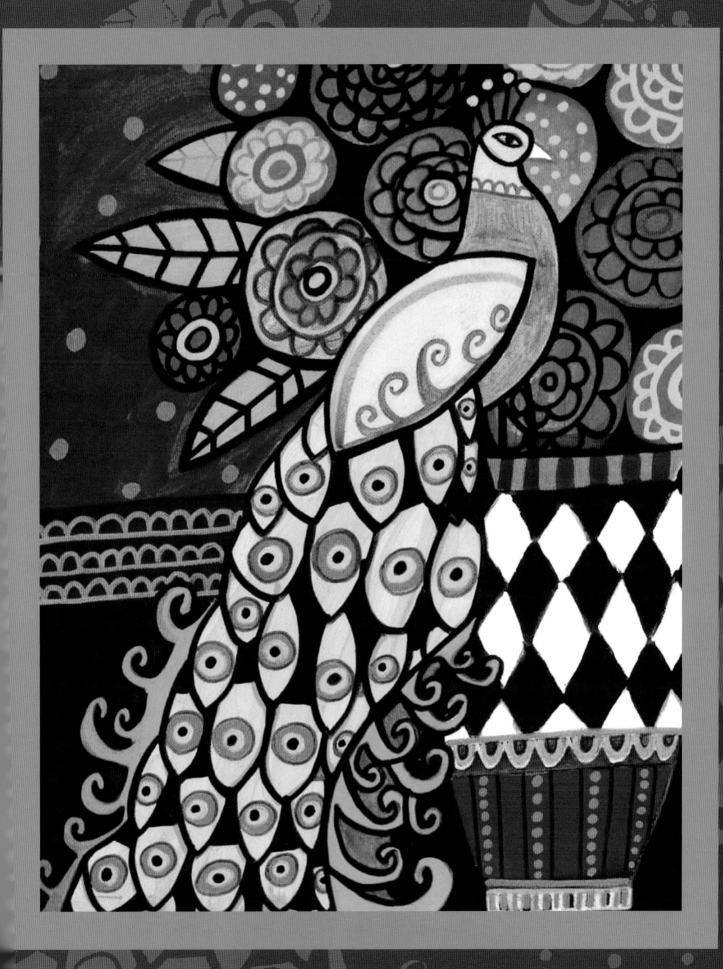

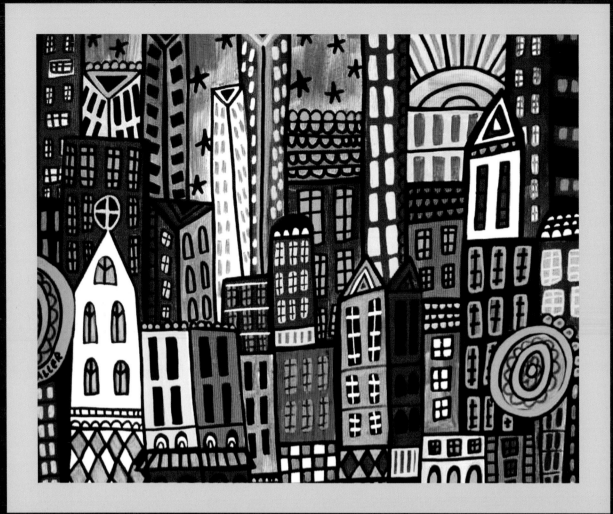
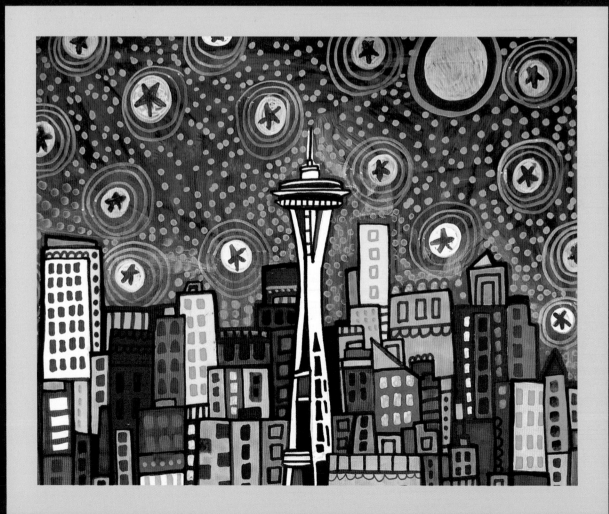

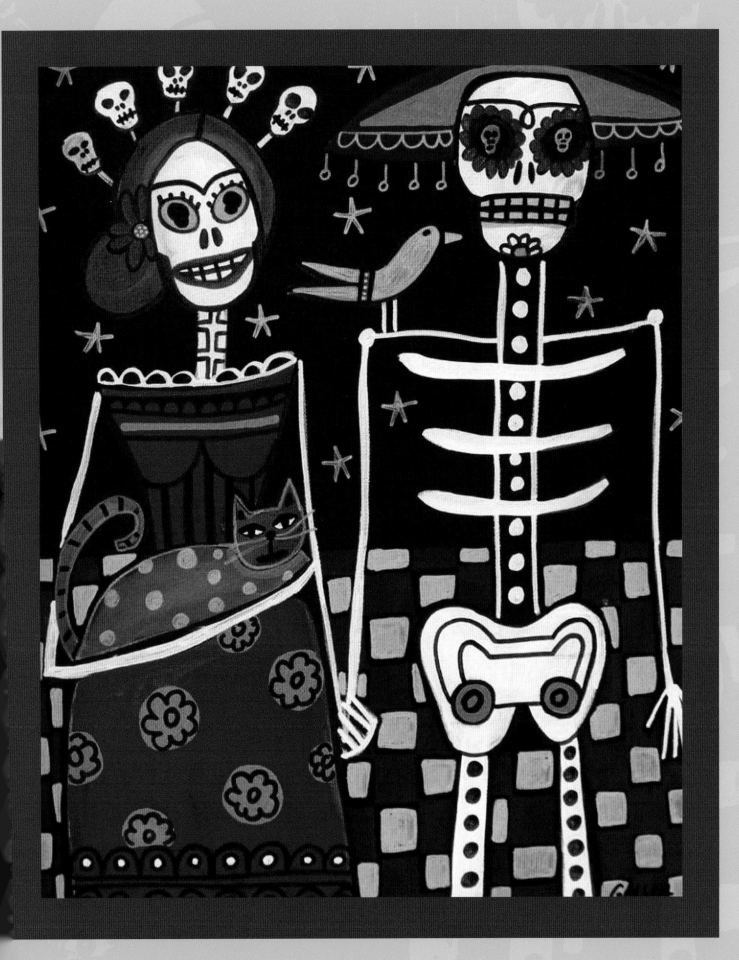

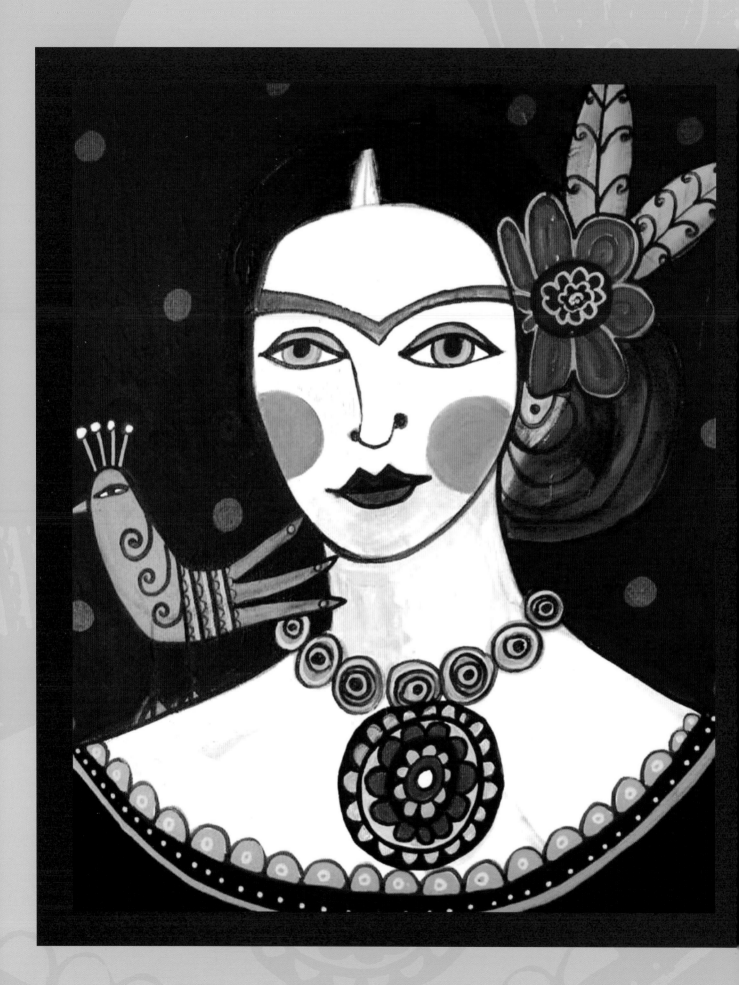

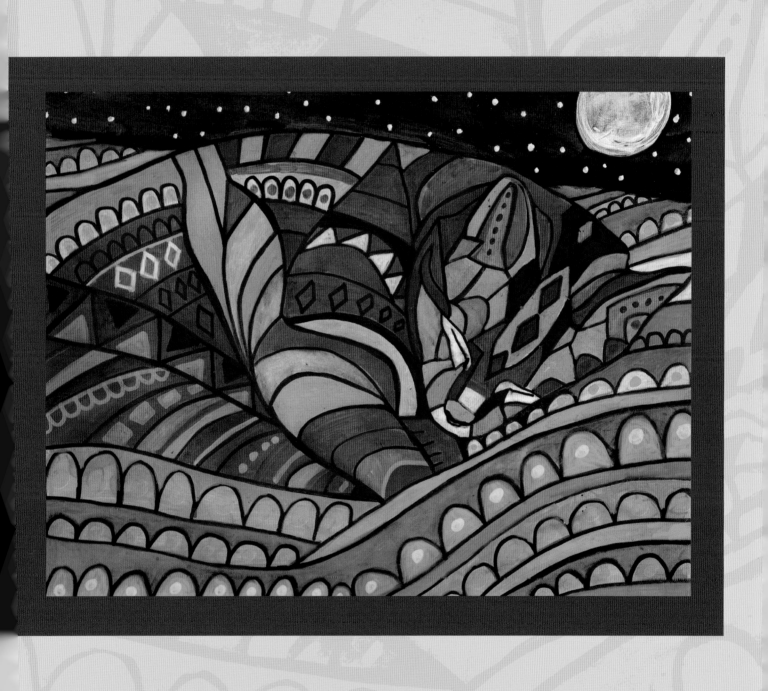

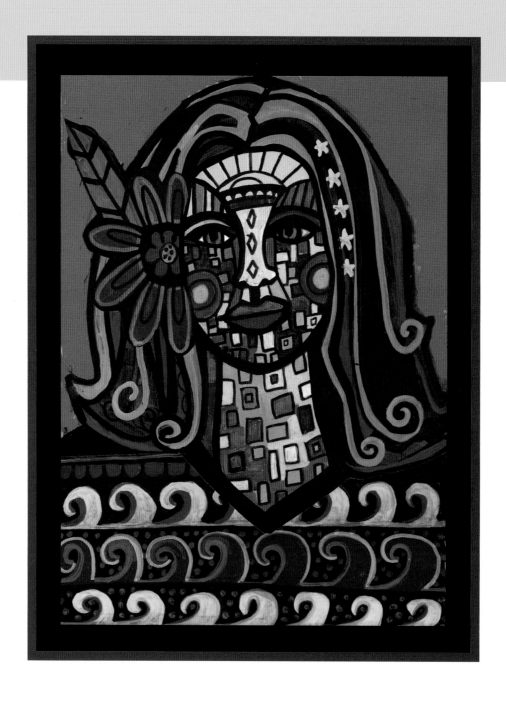

About the Artist

Heather Galler is a folk artist whose professional career has spanned more than three decades. Her unique works live with art collectors in every U.S. state as well as in 54 countries and 9,000 cities around the world. She has licensed her folk art to retailers such as Target. Heather's work can be found on USA Network, CBS, Nickelodeon, and Comedy Central. Visit her online at HeatherGallerArt.etsy.com